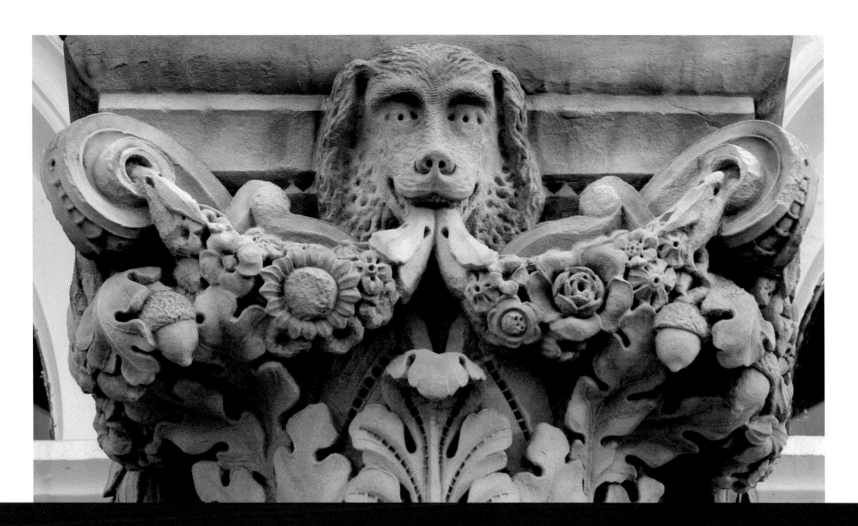

SAINT JOHN

PHOTOGRAPHY BY ROB ROY

NIMBUS
PUBLISHING

Nimbus Publishing Limited
PO Box 9166
Halifax, NS B3K 5M8
(902) 455-4286

Printed and bound in China
Design: Kate Westphal, Graphic Detail, Charlottetown, PEI

Front cover: Victorian homes on Germain St.
Back cover: The Palatine Building on Prince William Street.
Author photo: Irina Roy
Photo captions by Gary Hughes

Library and Archives Canada Cataloguing in Publication

Roy, Rob, 1953-
Saint John / Rob Roy.
Issued also in electronic format.
ISBN 978-1-55109-830-2

1. Saint John (N.B.)—Pictorial works. I. Title.

FC2497.37.R69 2013 971.5'32 C2012-907389-X

We acknowledge the financial support of the Government of Canada through the Book
Publishing Industry Development Program (BPIDP) and the Canada Council for our
publishing activities.

For the citizens of Saint John,
of both yesterday and today, who have created
the warmth and uniqueness of character
this city now preserves.

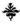

FOREWORD

Saint John Rises Again

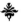

In 1864, a reporter for the *Halifax British Colonist* compared his city to Saint John after a brief visit:

Both cities engage in commerce, but in our city it holds a secondary place, in the other it is everything. The Halifax merchant is often indolent, always easy; the St. Johnian is eager, ardent, and untiring. He gives all his life up to business. He opens his shop or his office at an earlier hour, he risks more, speculates more, loses more, makes more; he fails in business oftener, but after failure he always manages to rise again and make another fortune....In Saint John there is no leisurely class. Everybody is hard at work. It is a city without loungers.

"It is a city without loungers." Has anything changed? Not much—at least in spirit—if looked at from Saint John's vantage point. Yet the wooden, ugly duckling city of 1864 would present a landscape that today's resident would find difficult to comprehend. The Great Fire of 1877 erased much of that city and created the instant, late nineteenth-century downtown core of brick and stone so familiar today. And just as the city rose from those ashes and from the many other destructive fires of the century, it rises today as a city

in transition, from an industrial powerhouse to a regional, service-based centre.

It is this spirit of rising again, of never giving in, that distinguishes Saint John. Its blessings are not those of a provincial capital; as a result, its traditions, whether in the religious, political, military or educational spheres, are decidedly anti-establishment. Not that it has been uninterested in claiming the capital city title. In 1858, a group of merchants and politicians (often one and the same), almost wrested the provincial capital away from Fredericton. And this is the city where, in the mid-nineteenth century, the low church Anglicans of Trinity Church defied Fredericton bishop John Medley's high church program of Tractarian Gothic architecture. The original neo-classical architecture was retained and refined; it stood until swept away by the 1877 fire. Only then did the Gothic triumph. And in the mid-twentieth century, a group of community leaders pressured the University of New Brunswick in Fredericton to open a branch in Saint John in 1964. Now that branch is growing faster than the parent in undergraduate enrolment and one of its leading departments is, no surprise, the School of Business.

In the early 1970s the heritage movement sprang to life, prompted by the loss of several historic buildings, and its efforts culminated in the establishment of the Trinity Royal Preservation District in the city centre. Elsewhere, the retreat of industry from large stretches of harbourfront in the twentieth century had left neglected shores, prompting the formation of the Saint John Waterfront Development Partnership as the new century began. The spirit that once turned engine wheels then went to work opening and modernizing an area pockmarked by rotting timber wharves from the early nineteen hundreds. The result has been the installation of a spectacular harbour walk with interpretive signage and other amenities. A second phase is in the works. "It is a city without loungers. Everybody is hard at work." But Saint John is not the ugly duckling of 1864. It is, rather, a place where views from hilltops are inspiring, building heritage is nationally recognized, gardens grow and people are thriving.

Gary Hughes
Curator, History and Technology
New Brunswick Museum

This is an outstanding example of British Neo-classicism by local architect John Cunningham. His Saint John County Court House was designed in 1824 and completed in 1830. Its front façade offers the suggestion of a central temple front pavilion with Greek Doric pilasters, triglyphs, and a pediment. The earlier British Palladian style of the eighteenth century would have had this feature jutting out from the building, but Neo-classicism was more subtle and Cunningham was a master of the medium. As built, it was a reminder of the British fact in a Loyalist colony.

INTRODUCTION

The Cultural and Industrial Heritage of Saint John, New Brunswick

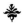

Saint John, New Brunswick, is a modest city. Nestled at the mouth of the Saint John River, it resolutely bears the capricious weather off the Bay of Fundy. Hewn from the unforgiving rocky shore, the decisively geometric layout of Saint John's streets attests to the determination of its original settlers. This conviction makes Saint John proud of its past and keeps its traditions alive.

The written history of Saint John dates to 1604. Archaeological evidence of inhabitancy, however, has been dated to a period roughly four thousand years ago. A site on the edge of the harbour has shown signs of occupation by the Red Paint People, a group named for the red ochre or iron oxide earth they used for decoration. The Wolastoqiyik, the area's first permanent inhabitants, have lived along the river they named the Wolastoq (the good river) for at least fifteen hundred years. They would portage around the curiously reversing falls at the river's mouth and gather at the harbour during the summer months.

It was this gathering place that Samuel de Champlain described in the first recorded instance of European exploration of the area in 1604. Champlain, the official cartographer from a French expedition led by Pierre Dugua, Sieur de Mons, made a map of the area when his group entered the harbour and surveyed the mouth of the river on June 24, the feast day of John the Baptist. Some accounts relate that on the shore they came to a Wolastoqiyik village, Ouigoudi, and traded with the chieftain, Chkoudoun. Thus began an association that would prove fortuitous for the French and lead the way in the European settlement of the region.

A little over a quarter of a century later, the French established a more permanent presence in the area. By the end of 1632, a fortification was built on the shore of the harbour by Charles de St. Etienne de La Tour, an ambitious and powerful trader. One of the most poignant episodes in Saint John's history is the desperate struggle of La Tour's wife, Françoise-Marie Jacquelin, who attempted the defence of the fort during her husband's absence. In the spring of 1645, Charles de Menou d'Aulnay, La Tour's rival, besieged the fort, captured it, and breaking his promise of clemency, executed all the prisoners while forcing Jacquelin to watch. She did not long survive the defeat; three weeks later she died while imprisoned.

The British era began more than a century later, in 1758, when the small French settlement at the mouth of the river was captured and dispersed by troops under the command of Colonel Robert Monckton. A new fortification, Fort Frederick, was built on the west side of the harbour and about three hundred soldiers were stationed there. In 1762, a group of New England traders and merchants established a trading post to take advantage of the vast resources of fur and timber that made their way down the river. Life in the settlement was not easy. The frequent attacks by marauding privateers from New England culminated in the destruction of Fort Frederick in 1775 while its defences were weakened—their troops had been called to fight the rebels in New England. Only after 1778, when Fort Howe was constructed on a strategically prominent hill overlooking the harbour, was there really effective defence of the settlement.

The end of the American Revolutionary War marked the most dramatic change for Saint John. In the spring of 1783, a fleet of ships arrived in the harbour from the American states carrying the first of fourteen thousand refugees loyal to the British Crown. Today, May 18 is celebrated as Loyalist Day in Saint John.

Originally, there were two Loyalist settlements established at the mouth of the

The Saint John Harbour Bridge frames uptown Saint John on a summer's evening. This view is taken from the Harbour Passage Trail which winds its way under the bridge to the buildings in the distance.

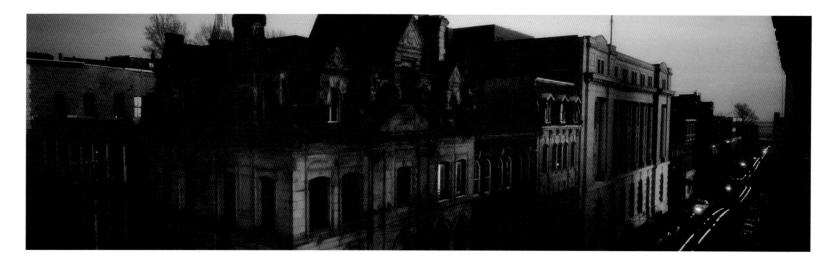

Saint John River: Parr Town and, on the opposite side of the harbour, Carleton. After New Brunswick was partitioned from Nova Scotia in 1784, a royal charter was granted by King George III and the two towns were combined to form Canada's first incorporated city—Saint John. Although it was considered the most likely location for the seat of the province's government, Saint John's heated political struggles compelled the governor to choose Fredericton, ninety-six kilometres up the Saint John River, as the provincial capital. Despite this early setback, the city's ideal location resulted in its steady growth, both in population and industry, throughout the late eighteenth and early nineteenth centuries.

As New Brunswick's major port city, Saint John experienced both the promise and tribulation that accompany immigration. Great influxes of people have shaped the city's character in all periods of its development. In the late 1700s, Scottish and English immigrants were accommodated within a popula-

tion similar in language and religion. Not so easily absorbed into the fabric of the city were the great waves of destitute emigrants from Ireland, who needed assistance in their attempt to escape the desperation of the potato famines of the 1830s and 1840s. The stress placed upon the city erupted in one of its most ignominious incidents—the riots between Protestant and Catholic Irish on July 12, 1849, when violence claimed at least a dozen victims. Today, Saint John celebrates its cultural diversity in a week-long festival that encourages the understanding and appreciation of its ethnic mosaic.

Like most major cities in the 1800s, Saint John saw its share of destructive fires. The conflagrations of 1837 and 1877 razed the central core of the city but relief efforts and civic pride spurred a great rebuilding. As a result, there are sections of the city that have changed little in the last century, retaining some of the best examples of late nineteenth-century architecture in Atlantic Canada. The Victorian charm at the city's centre is accentu-

ated by urban renewal efforts that began in the 1960s, amalgamation with neighbouring villages, and the development of burgeoning suburbs.

The city had always been New Brunswick's most industrialized area, and new approaches to attracting investment ensured that this role would continue. Saint John undertook to promote its location as one of only two ice-free winter ports in Eastern Canada, and also advocated its advantages as a tourist destination. An important terminus on contemporary transportation systems, the city continues to play a role in international trade.

Still the major port on the Bay of Fundy and the largest city in New Brunswick, Saint John maintains its position as one of the most significant urban influences on the social, economic, political, and cultural life of the Maritimes.

Peter J. Larocque
Curator, New Brunswick Cultural History and Art New Brunswick Museum

Above: Prague, London, Budapest? No…Saint John's Prince William Street at dusk.

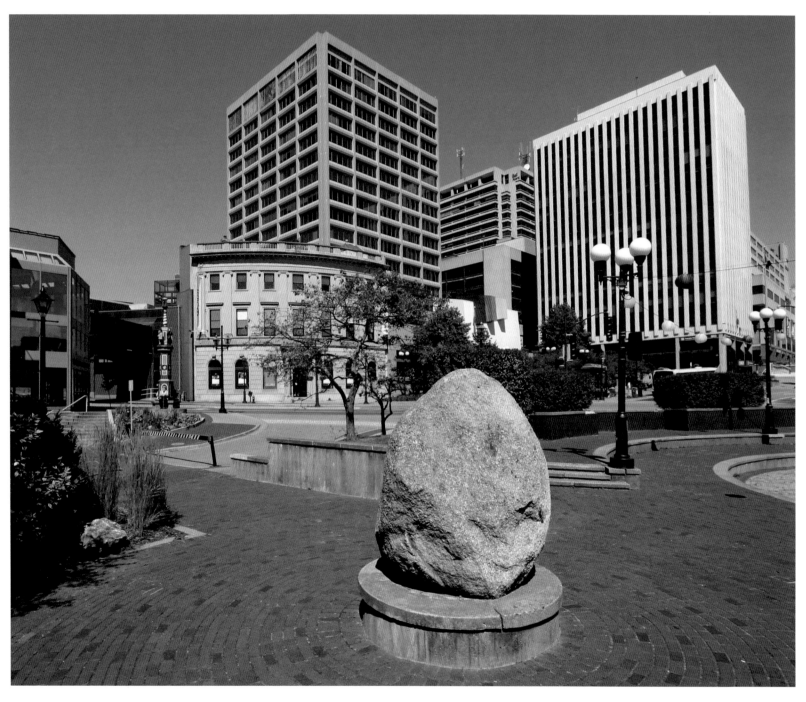

Market Square's public space faces an audience of city towers. A host to entertainment from buskers to concerts, it occupies ground that was once a slip for schooners and wood boats. A hundred years earlier it was the site of the landing of Loyalists from the middle colonies of the new United States. The stone monument to the left has a plaque on the other side honouring these refugees of 1783 who braved a cold winter in tents and huts waiting for the spring and access to their lots upriver.

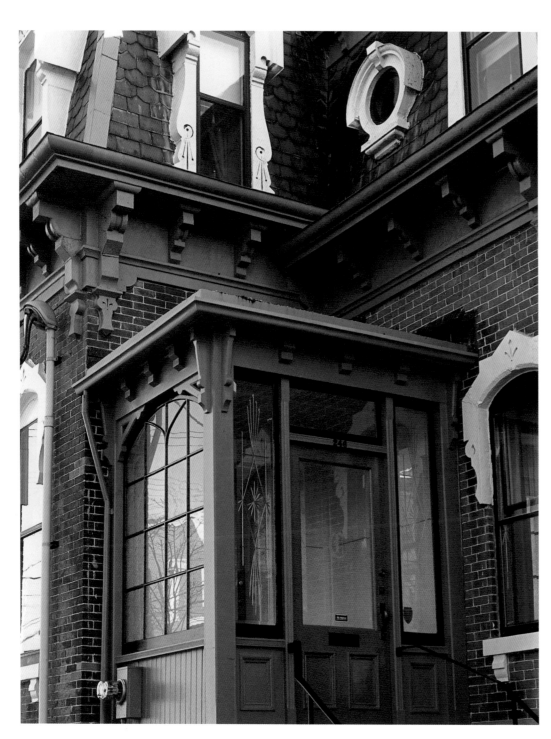

This rear entry porch graces a mansard roofed cottage designed by the firm of Croff & Camp of Saratoga Springs, New York, following the Great Fire of 1877.

Facing page: A maze of wires cross the eye on Duke Street looking east to the Courtenay Bay crude terminal while the Irving Oil Refinery waits in the background.

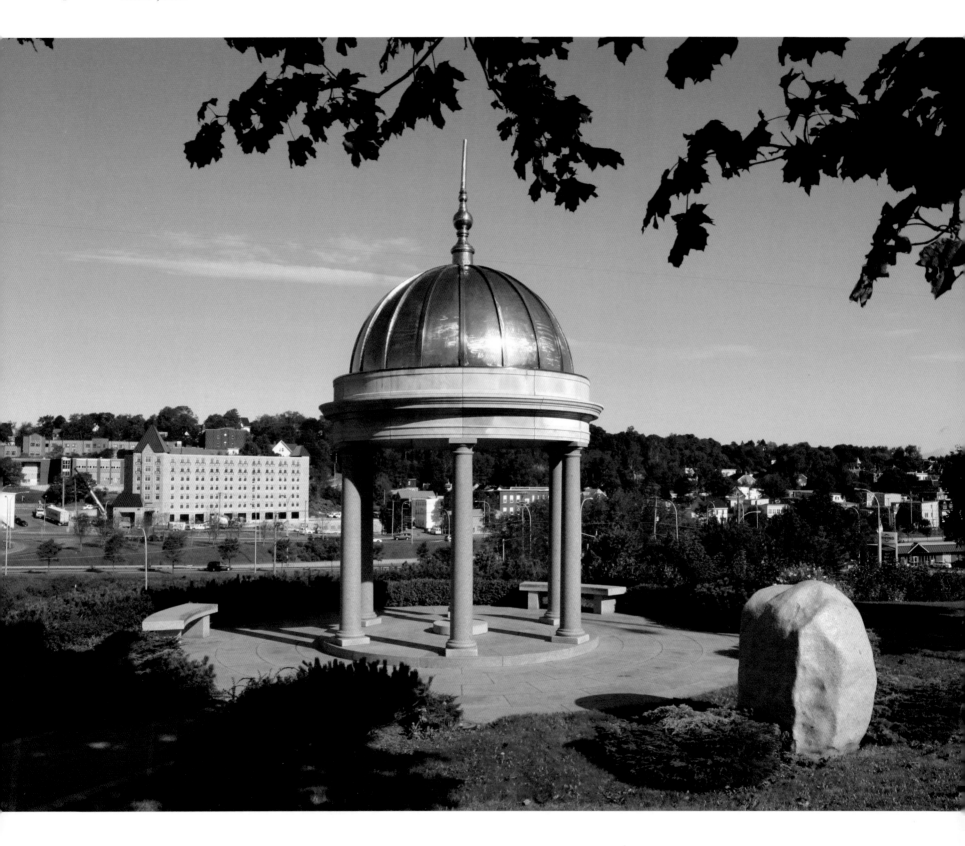

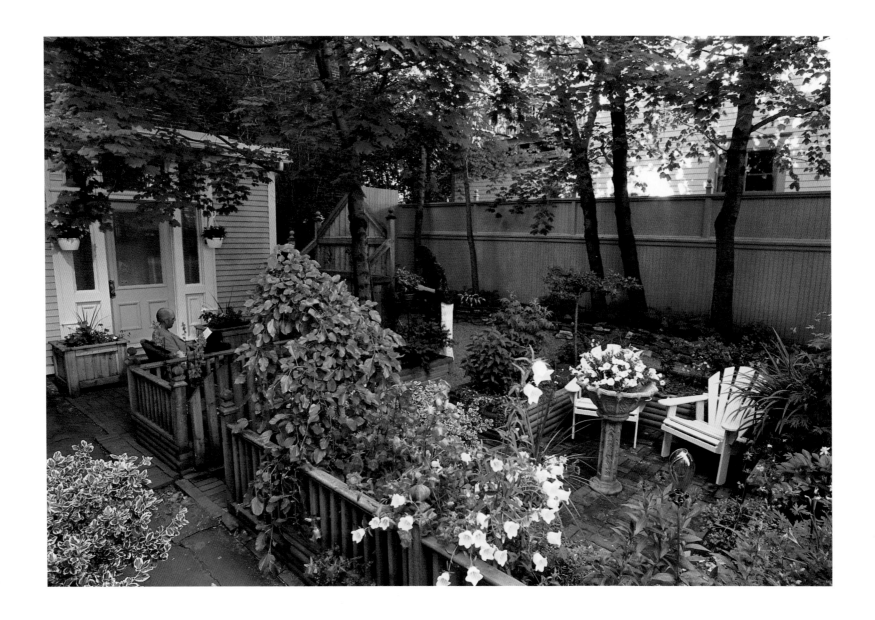

Summer sunshine provides a warm backdrop to this Carmarthen Street shade garden, a colourful oasis amidst the bustle of city life.

Facing page: The Saint John General Hospital Dome watches over the city's north end as evening falls, a reminder of the large Art Deco building that once stood on Waterloo Street and served as a stage for so many life passages over the years. In the left background is the Chateau Saint John hotel.

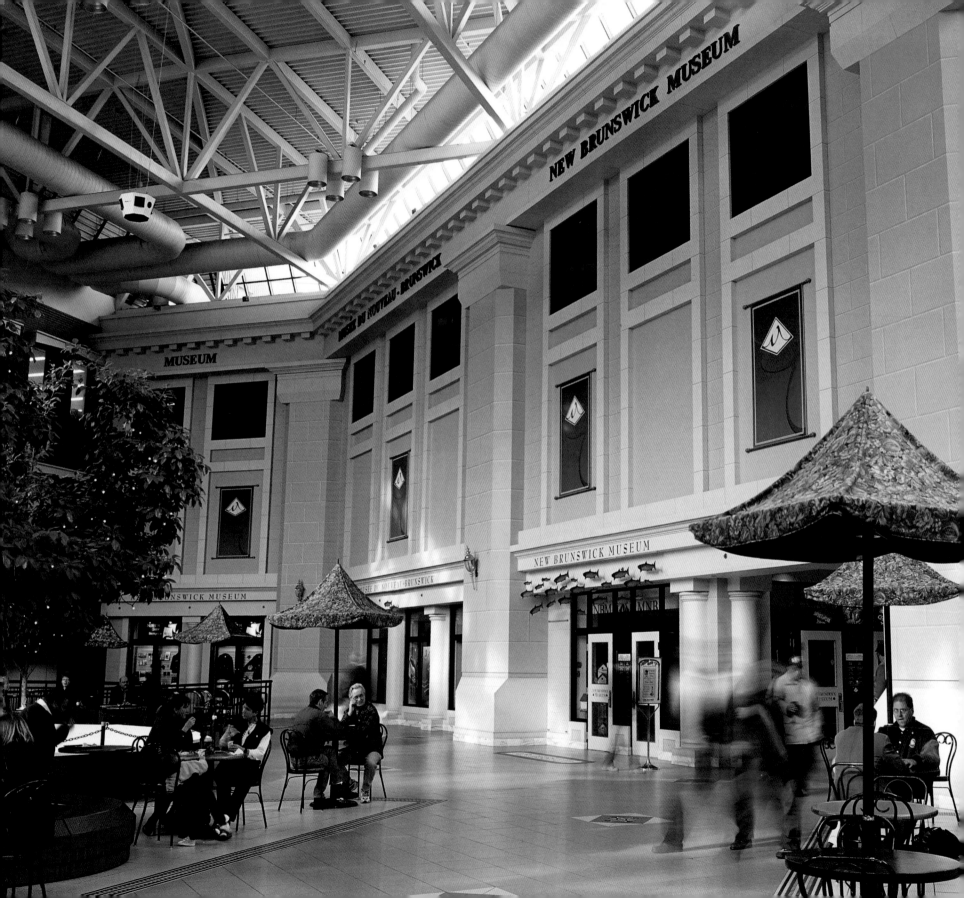

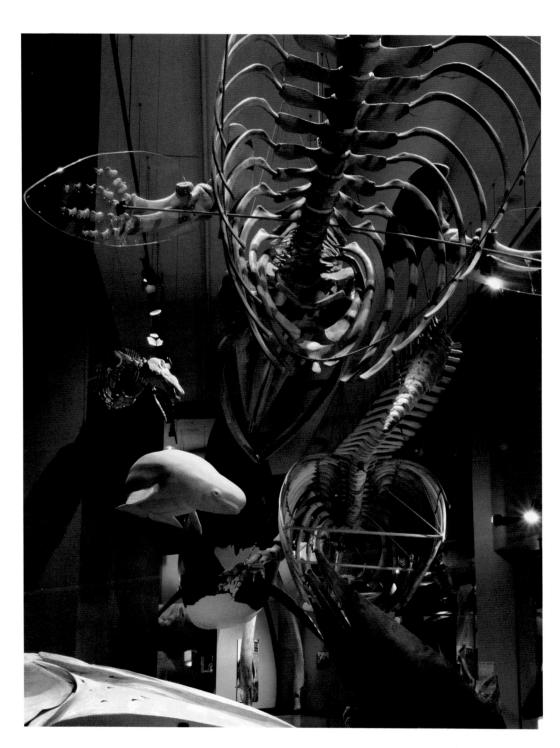

The Hall of the Great Whales in the New Brunswick Museum is one of many displays responsible for drawing thousands of visitors every year. Founded in 1842, it is Canada's oldest museum. (Courtesy N.B. Museum –Photo by R. Roy)

Facing page: The Market Square branch of the New Brunswick Museum opened in the spring of 1996 with more than 50,000 square feet of exhibition space. This increase in display and interpretation capacity was a welcome change, allowing more public access to the museum's important collections of New Brunswick, Canadian, and foreign artifacts, specimens, and documents.

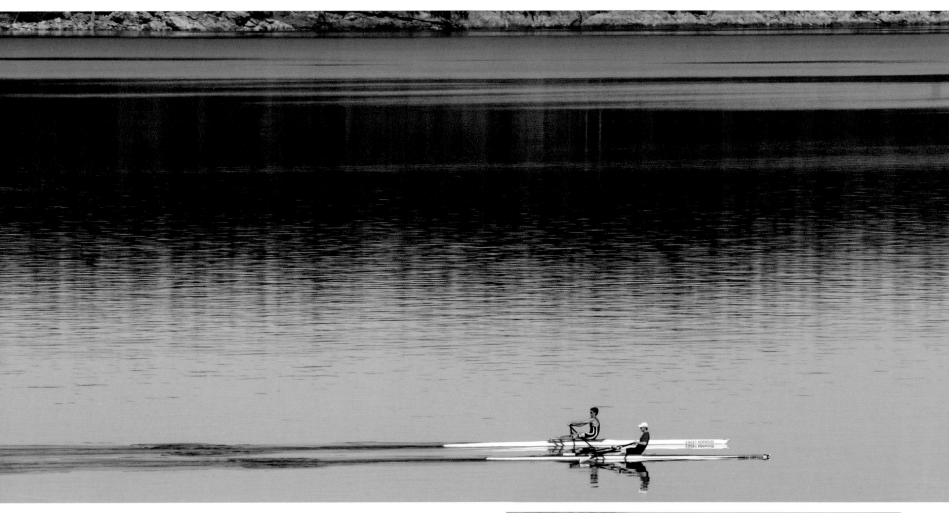

Two scullers cut the water on the Kennebecasis River at Renforth east of the city. The rowing tradition in Saint John is long and proud, beginning with races between groups of timber raftsmen in the the harbour during the mid-nineteenth century.

Relaxing on Renforth Wharf on a summer's day with Long Island in the background.

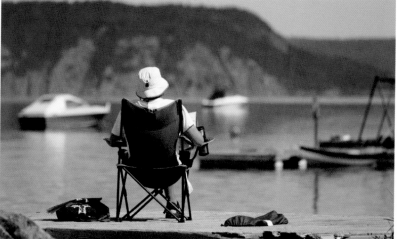

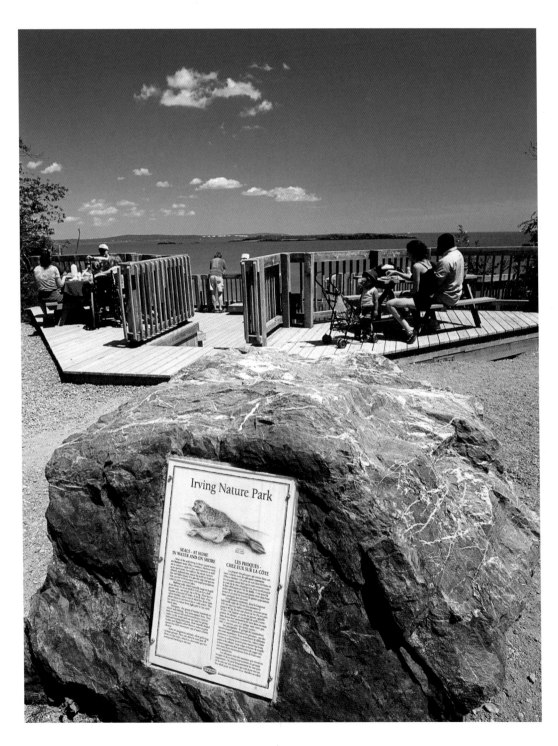

The Irving Nature Park was established in the 1990s. It includes a sweep of sea beach on the Bay of Fundy leading to an entire peninsula of driving and walking trails interspersed with picnic spots and lookouts.

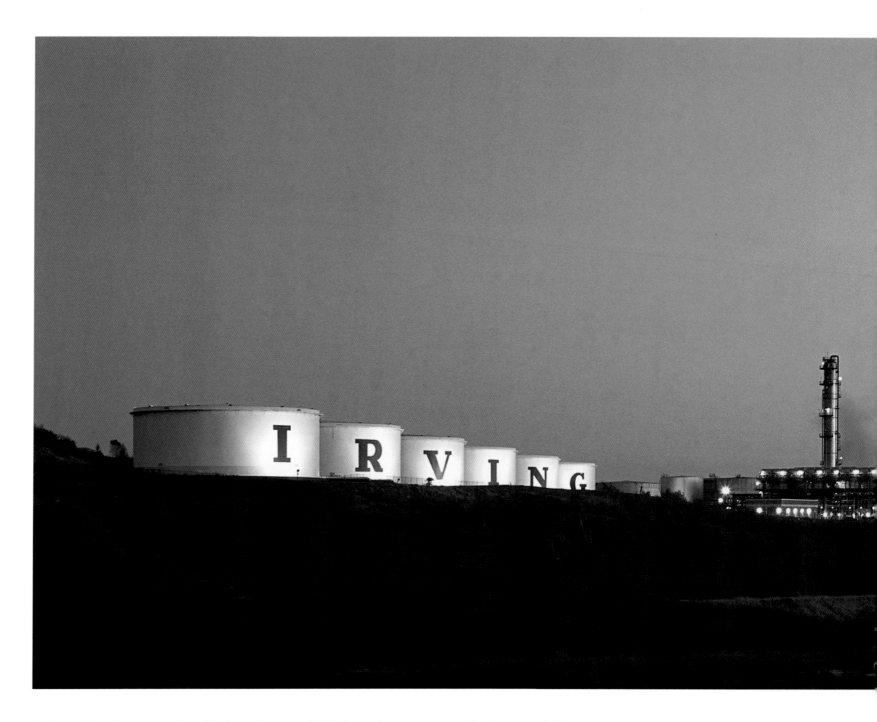

Irving opened an oil refinery in east Saint John during the summer of 1960. Through the years, it has expanded to become Canada's largest.

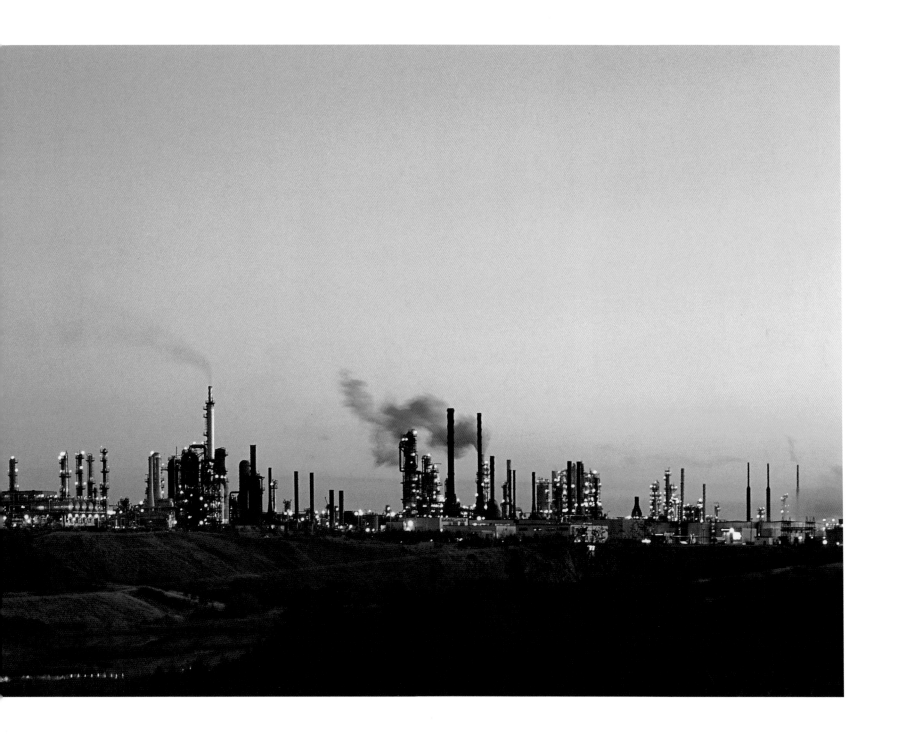

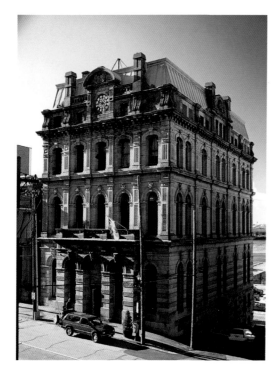

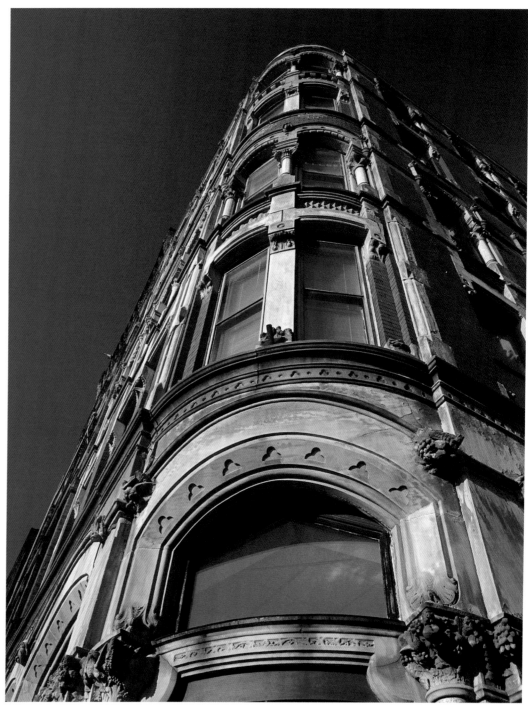

Above: The impressive Second Empire sandstone post office on Prince William Street was Saint John architect Matthew Stead's finest building in the city. Designed in 1877 just after the Great Fire, it was finished in 1881, two years after the architect's death.

Looking up at the wrap-around façade of the Thomas Furlong building at the corner of Princess and Water streets. Furlong was a wine and spirit merchant who, like many other business owners, was burned out in the Great Fire of 1877. This attractive replacement with Gothic and Italianate accents is now being refurbished as an art gallery.

Facing page: Prince William Street is recognized nationally by Heritage Canada for its sweep of nineteenth-century buildings and the protection afforded them as part of the Trinity Royal Preservation District. The district also extends through several downtown blocks.

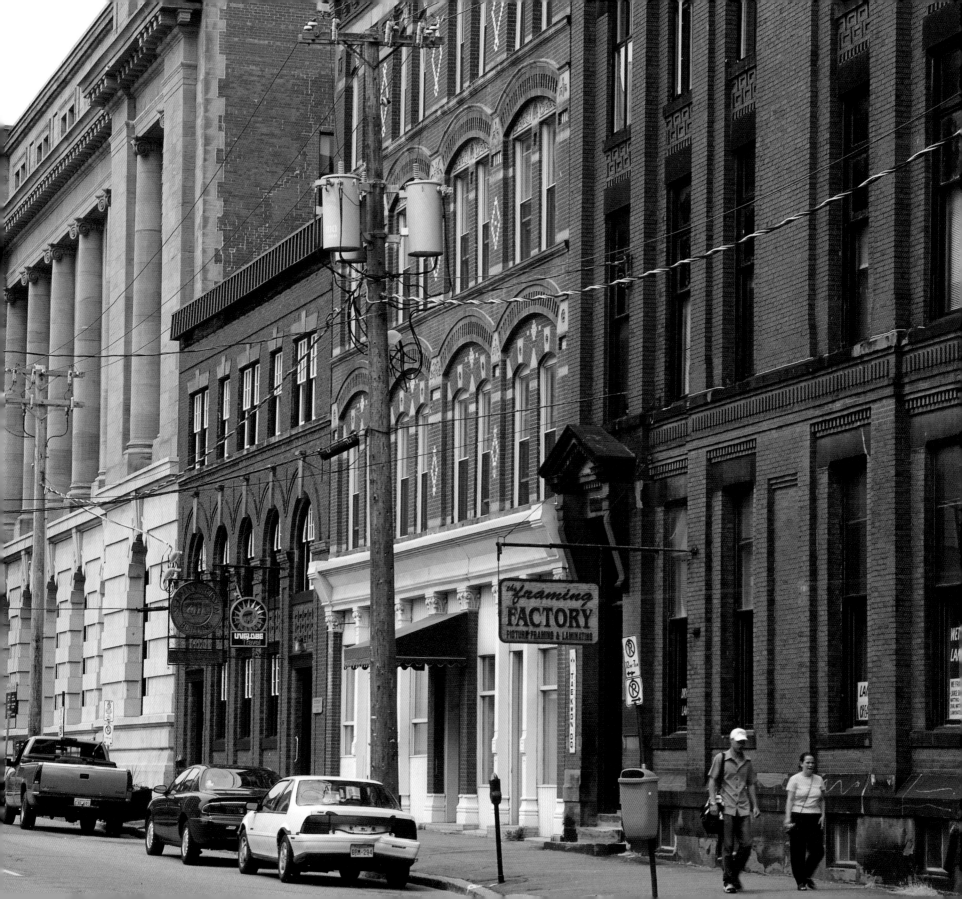

the framing
FACTORY
PICTURE FRAMING & LAMINATING

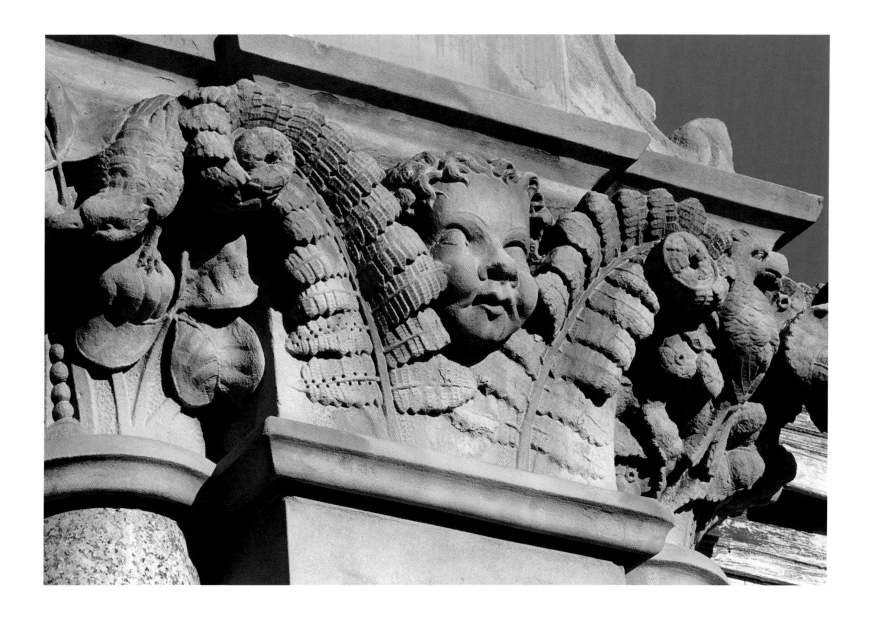

These grotesque capitals in sandstone surmount a sandstone pilaster at centre and red granite columns on this Prince William Street building from the late nineteenth century.

Facing page: Architect Matthew Stead chose a rose or wheel window as the principal source of light on the front end elevation of his Gothic design for the Cathedral of Immaculate Conception on Waterloo Street. The main body and tower of the church were completed in 1855 and the steeple in 1871.

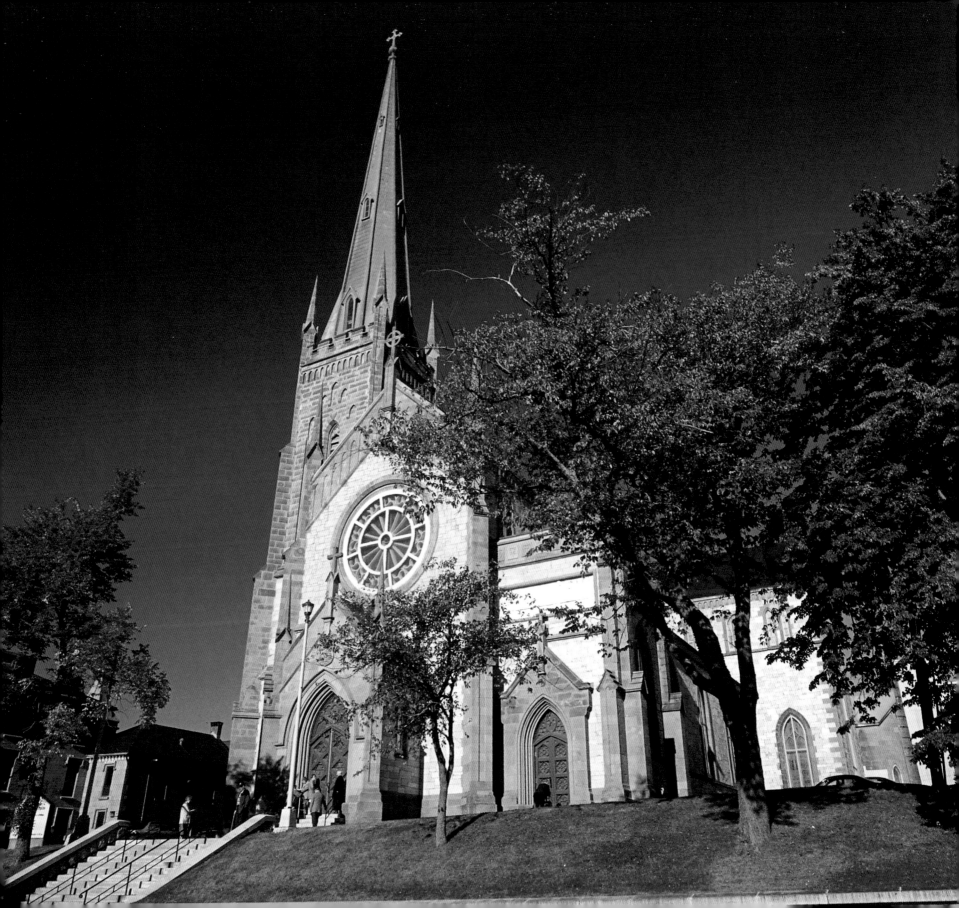

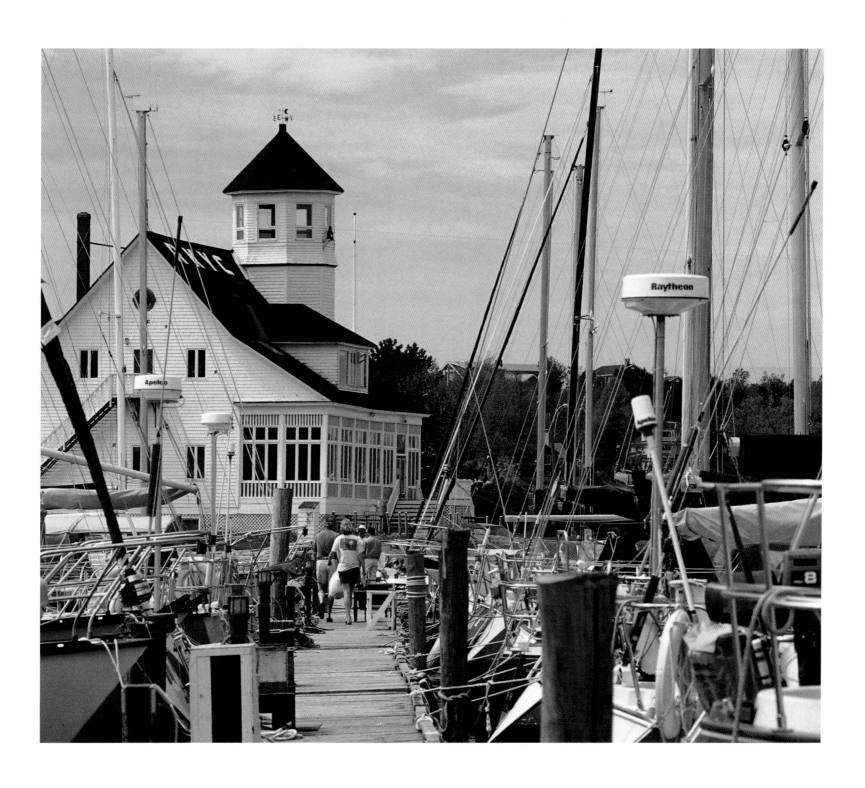

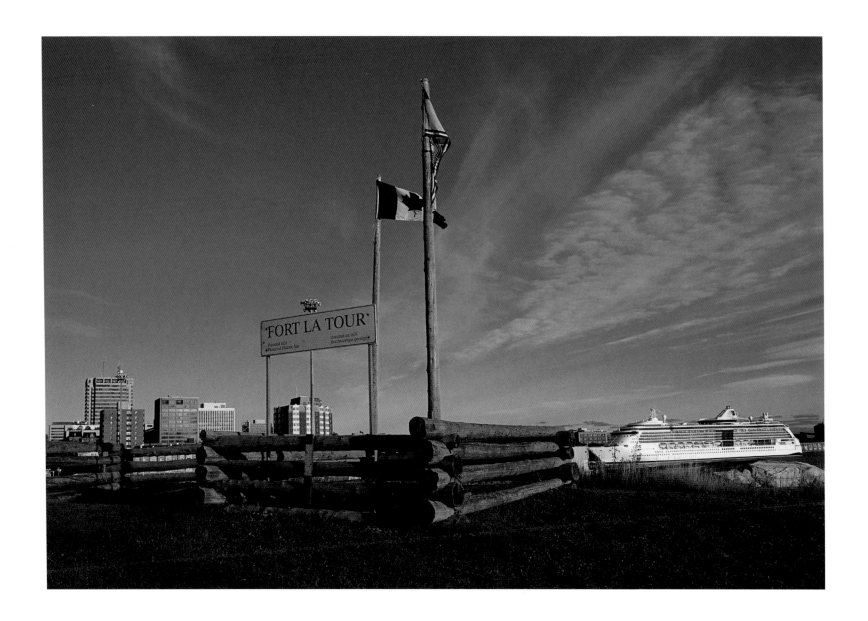

A log enclosure frames the site of Fort La Tour, a French trading post dating from 1632. The city centre can be seen at left, and a cruise ship at right.

Facing page: Masts and lines introduce the Royal Kennebecasis Yacht Clubhouse in the north end suburb of Millidgeville. The club was first established in the 1890s on the outskirts of town, taking advantage of a splendid waterway system that included the meeting of two rivers and a large bay.

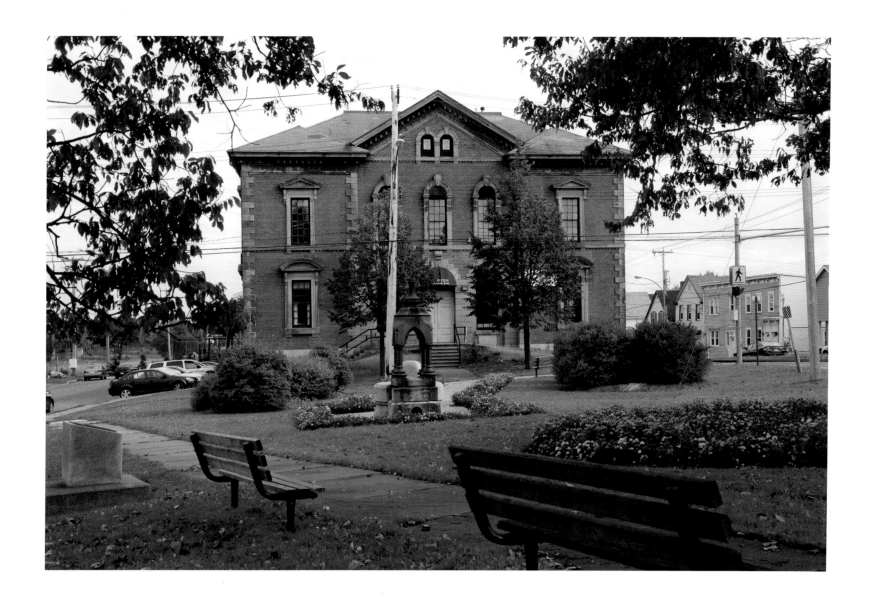

Originally the Carleton (West Side) Town Hall designed by Saint John architect Matthew Stead in 1863, it lost a storey to fire in 1923. Now the Carleton Community Centre, it was and still is in the Italianate palazzo style.

Facing page: The French explorer Samuel de Champlain sailed into Saint John Harbour on St. Jean Baptiste Day, 1604. The city traces its name to that event and Champlain was memorialized by this monument in Queen Square as part of the 300th anniversary celebrations in 1904.

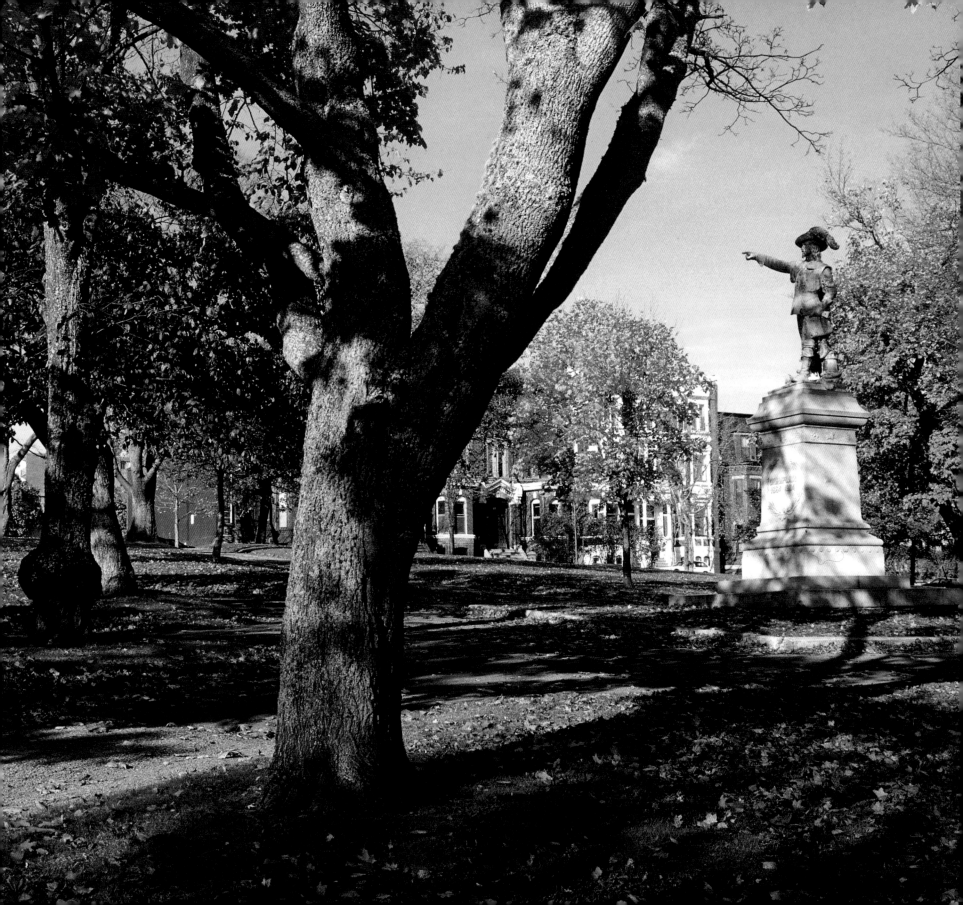

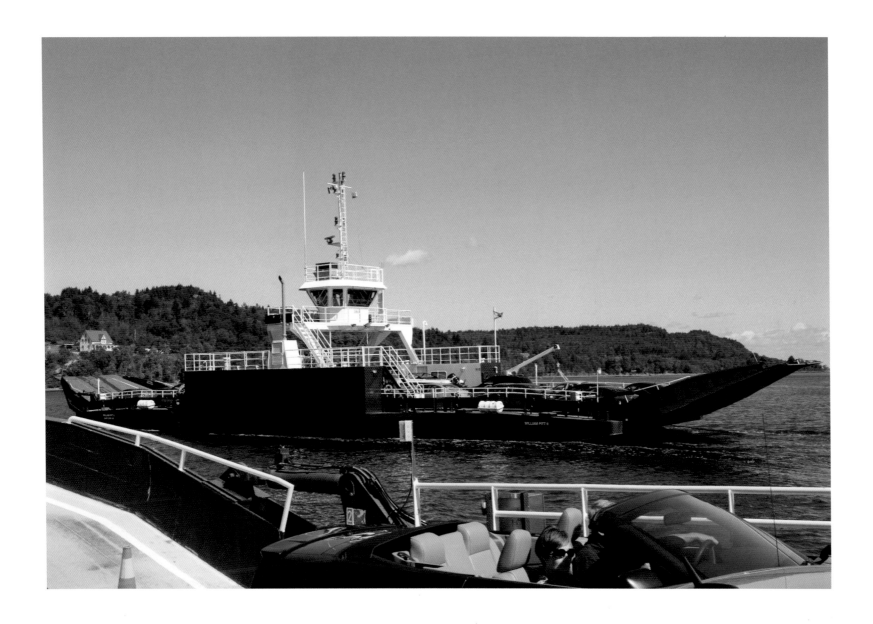

Two car ferries at Gondola Point connect the eastern suburbs with the Kingston Peninsula at left. Once a rural preserve, the peninsula has developed as a suburb itself during the past thirty years.

Facing page: A cruise ship docks on the eastern side of the harbour and a container ship waits to unload on the west. The downtown towers mark the city centre in the background.

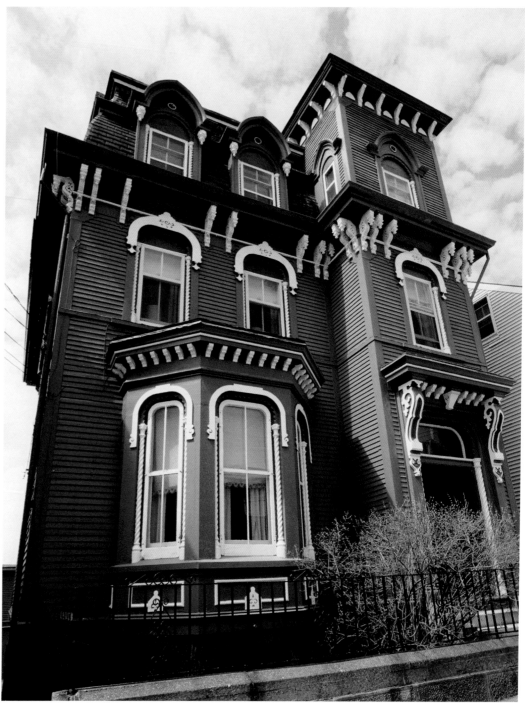

Above: Mercury, the winged symbol of the mails, out-stares the visitor from its keystone position over the doorway to the city's former post office building on Prince William Street. Designed and built following the Great Fire of 1877, it replaced a post office of similar size and style from 1876 that fell victim to the flames.

The mixture of Italianate and Gothic features on a mansard roof block with a projecting tower creates a wooden delight on Hazen Street, demonstrating the late nineteenth-century appetite for eclectic style.

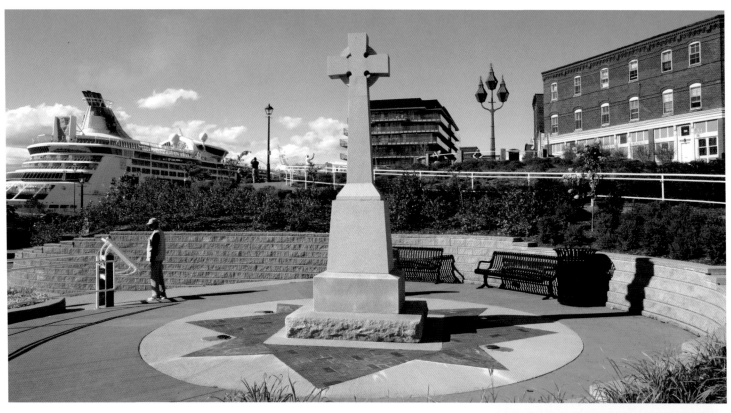

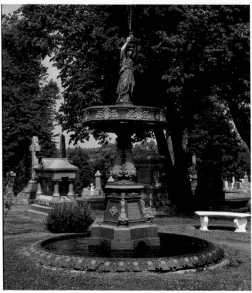

Above: Amidst the present tourist atmosphere of cruise ships stand two sentinels in St. Patrick's Square reminding visitors and locals of an alternative maritime past. In the foreground is a Celtic Cross, a smaller version of one standing on Partridge Island at the entrance to the harbour where Irish immigrants suffering from typhus and smallpox died by the hundreds in the 1840s. Behind are the Three Sisters, a beacon to mariners in wooden ships dating from 1848.

Fernhill Cemetery was designed and opened on the eastern outskirts of the city in 1848. Of special interest are its nineteenth- and early twentieth-century tombstones and memorial sculptures. Here is the Ruel Fountain in cast iron on a summer's day.

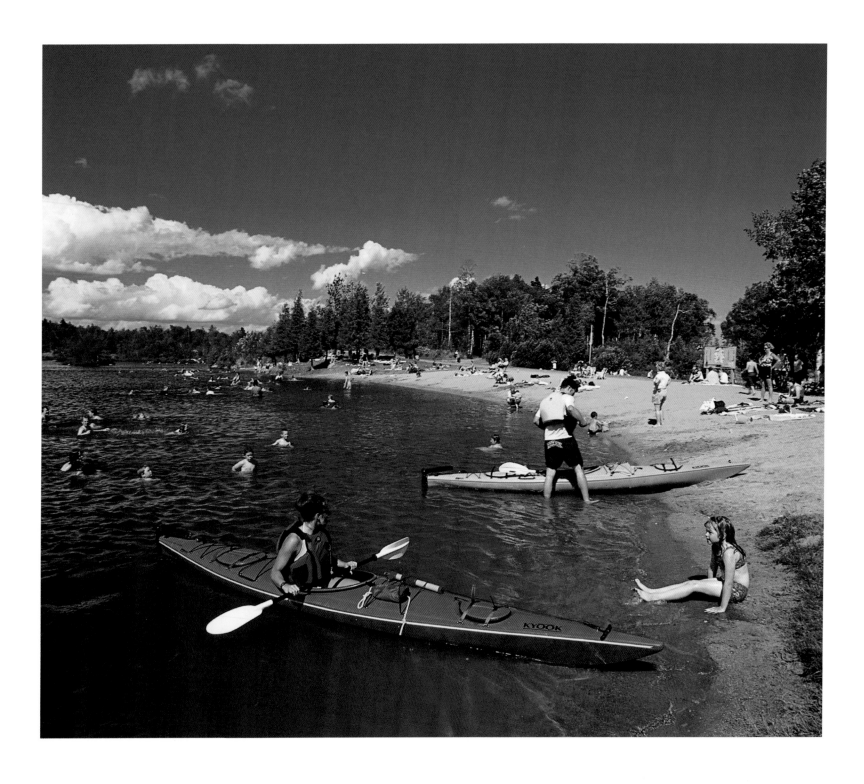

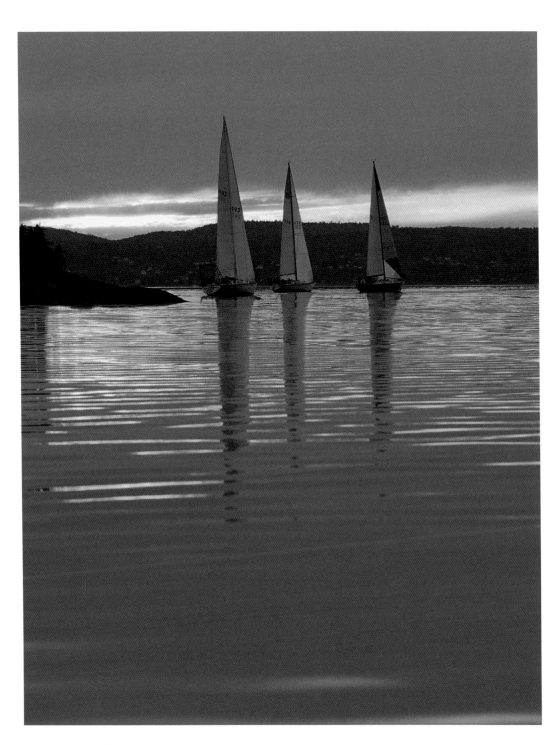

Sunset finds yachts on the Kennebecasis River. This waterway joins with the Saint John River at the city's northern boundary.

Facing page: Saint John boasts a series of artificial lakes within the confines of Rockwood Park in the northeastern portion of the city. The Fisher Lakes have provided a warm water recreational alternative for generations of Saint Johners, who can also choose the wider beaches and cooler water temperatures in the Bay of Fundy.

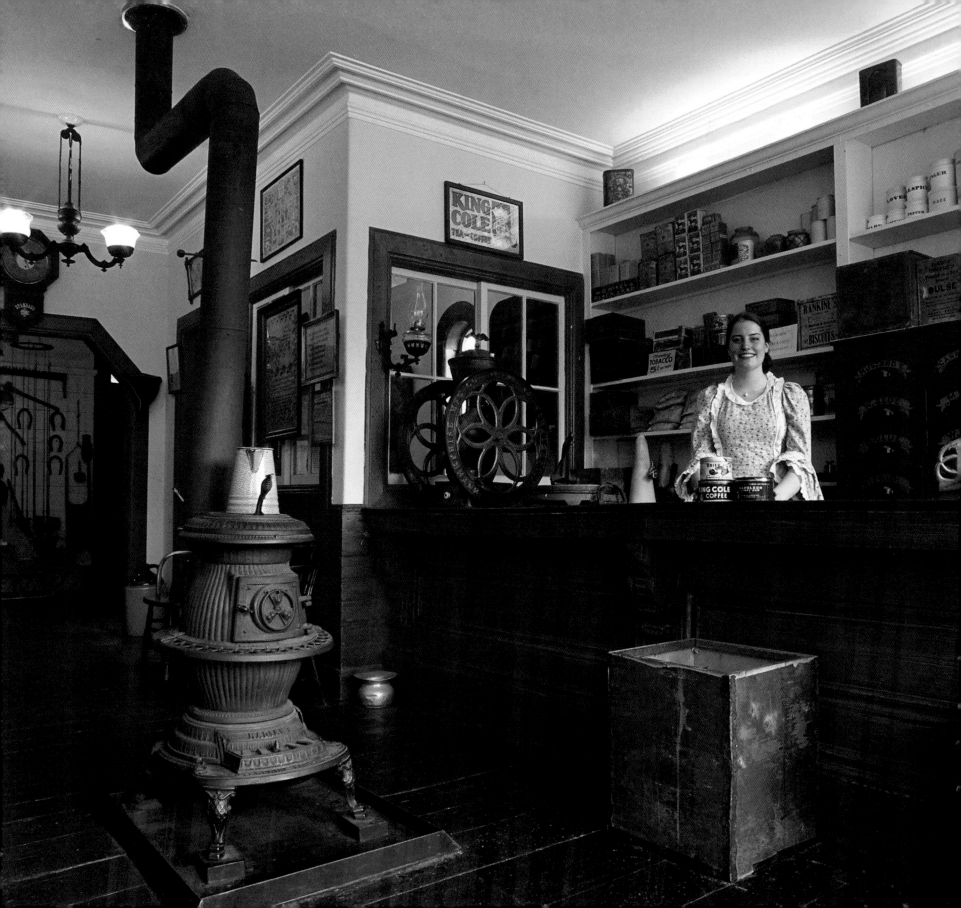

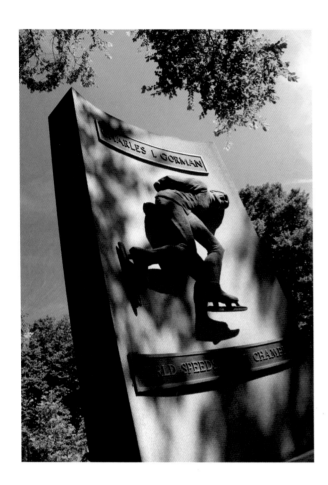

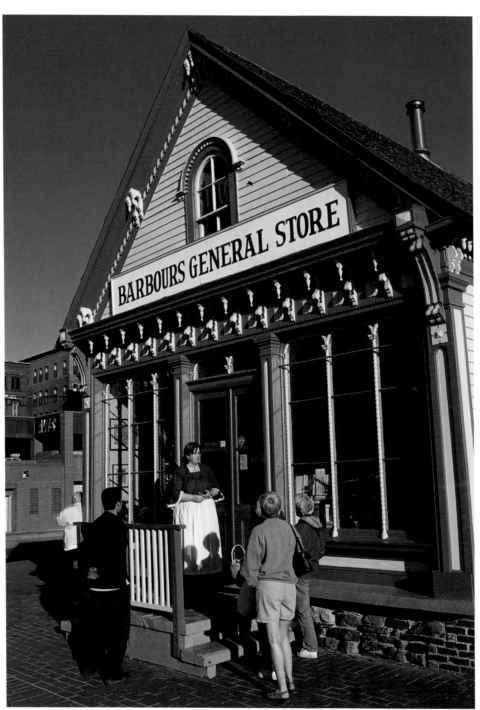

Above: This statue honours Saint John speed skater Charles Gorman in King's Square. Gorman won the world championship in 1927 at the outdoor course on Lily Lake before thousands of hometown fans.

Barbour's General Store has been a fixture in the Market Square area since it was moved to that location from an upriver rural site in 1967 as part of the city's centennial celebrations.

Facing page: An interior view of Barbour's General Store, which is outfitted with nineteenth-century commercial furniture, goods containers and, of course, a pot-bellied stove.

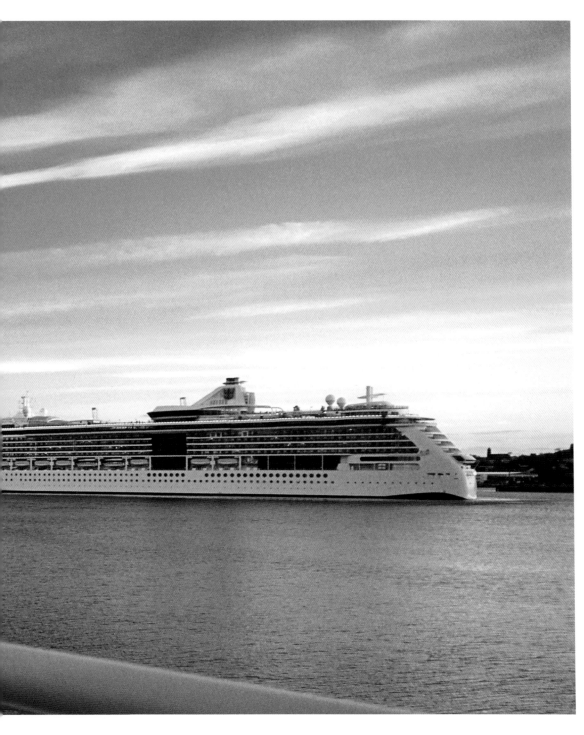

A cruise ship departs Saint John Harbour from the vantage point of the Market Square boardwalk.

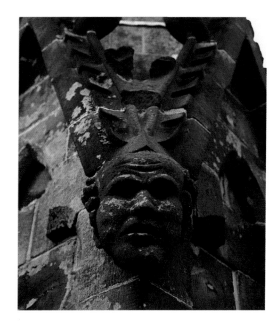

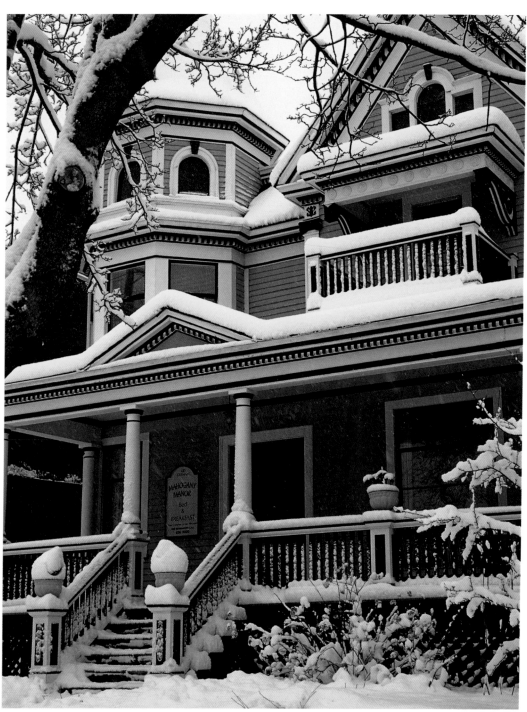

Above: Sculptural detail on bell tower finial of St. John's (stone) church.

This snow-wrapped late nineteenth-century Queen Anne home is now the Mahogany Manor Bed and Breakfast located on Germain Street near the city's downtown core.

Facing page: Iron fencing on Germain Street presents a woven geometric pattern against grey stone and red brick.

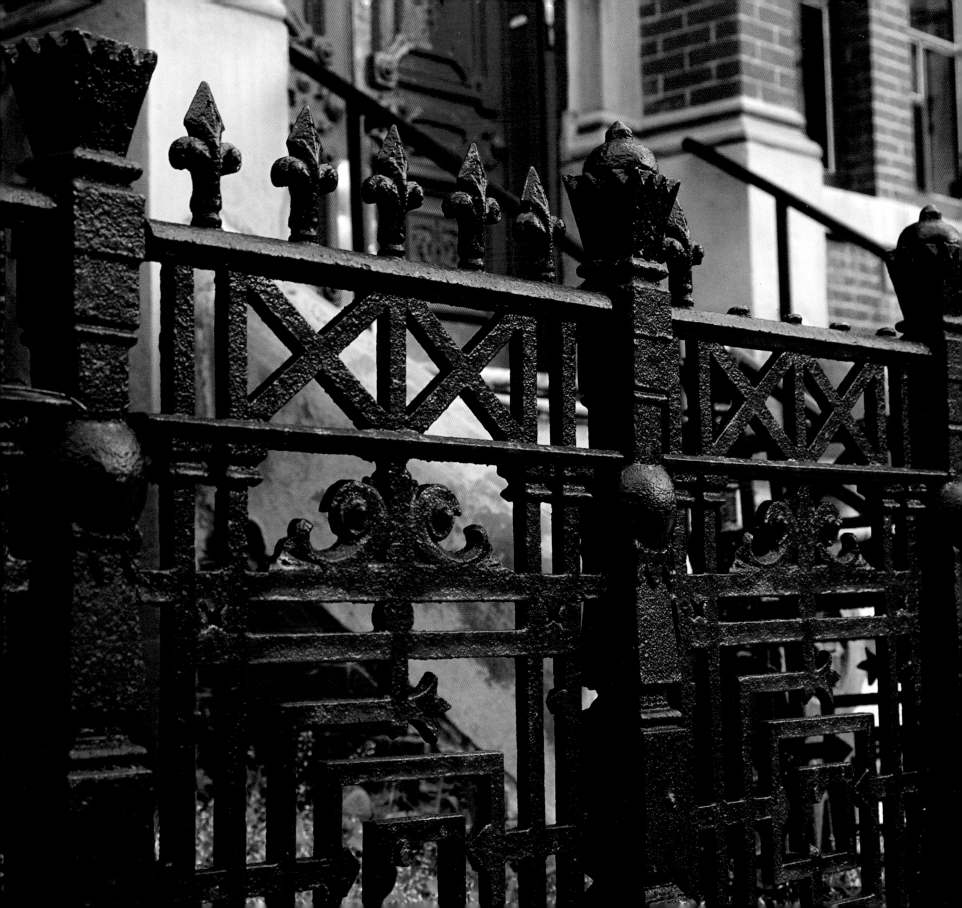

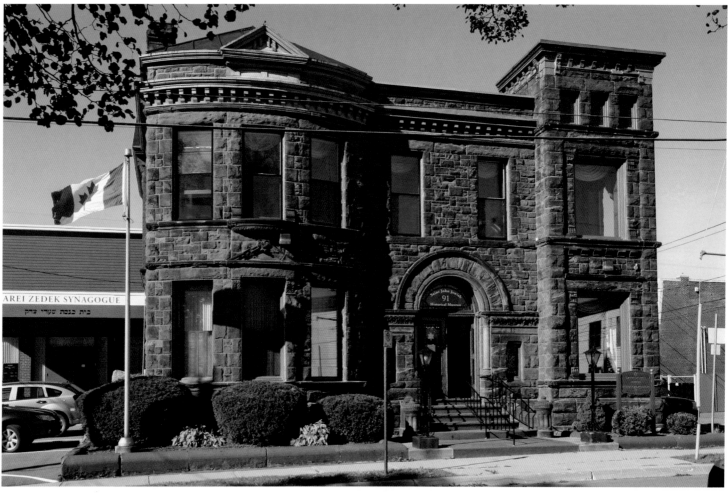

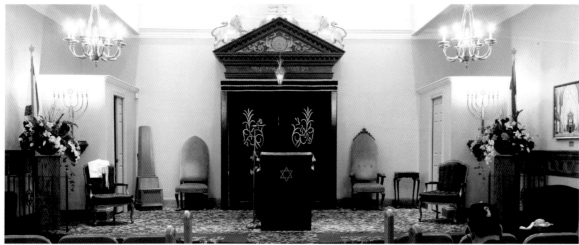

Above: The Shaari Zedek Synagogue is located in this turn-of-the-century maroon sandstone building on Leinster Street. Designed by Saint John architect H.H. Mott as a private residence, it now also houses the Saint John Jewish Historical Museum.

The sanctuary of the Shaari Zedek Synagogue located on Leinster Street near the city's uptown. The Jewish community in the city dates back to the mid-nineteenth century and the first synagogue to 1889.

This cross-gable Gothic Revival house from the 1850s in west Saint John is a good example of vernacular architecture—the adaptation of an architect's style to suit the ordinary citizen.

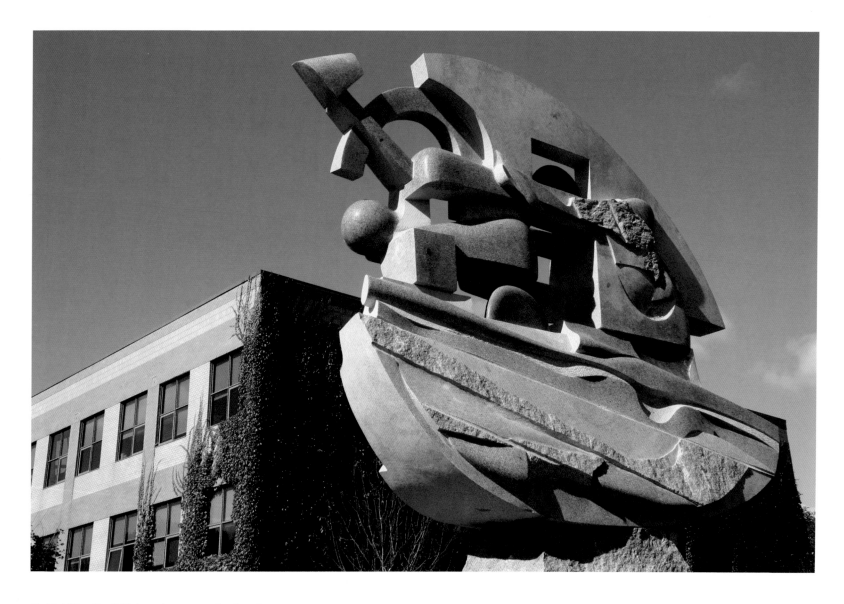

*Entitled "First Day," this is another stone carving from the
International Sculpture Symposium. John Gogaberishvili of
Georgia was the carver, and his work has been installed at the
University of New Brunswick, Saint John.*

*Facing page: The K.C. Irving building has contributed
significantly to the fast growth of Saint John's University of
New Brunswick (UNBSJ) campus in its suburban north-end
location.*

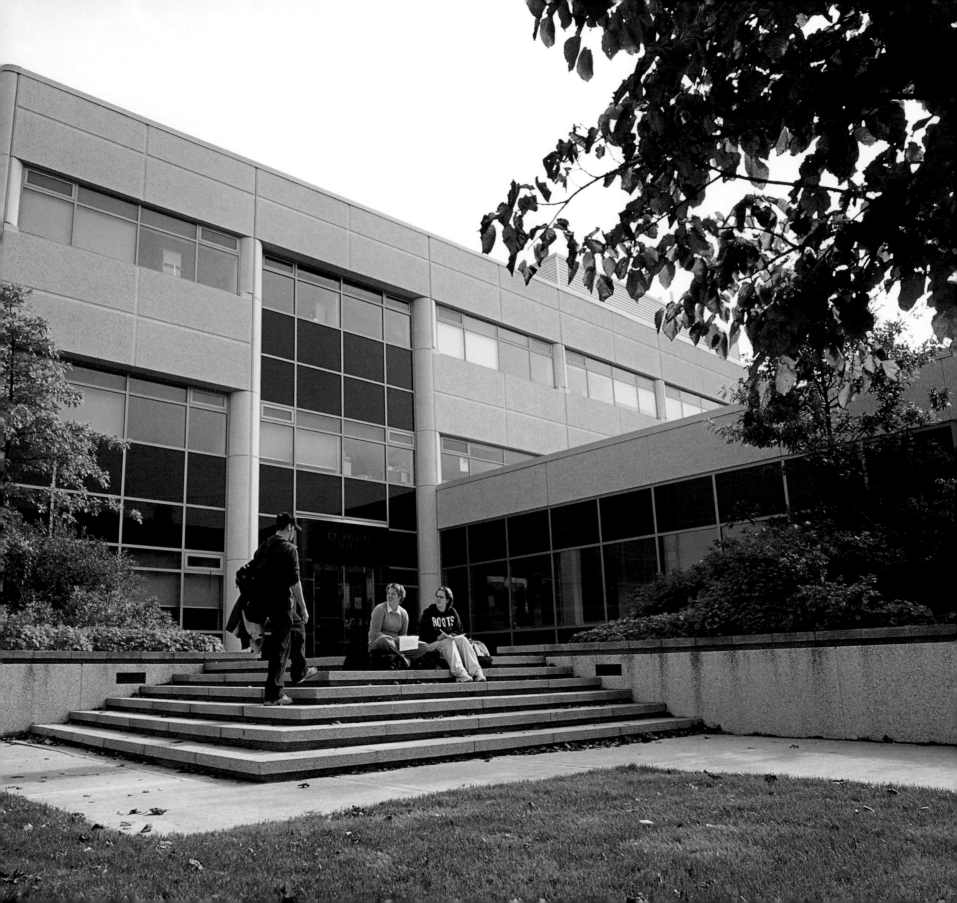

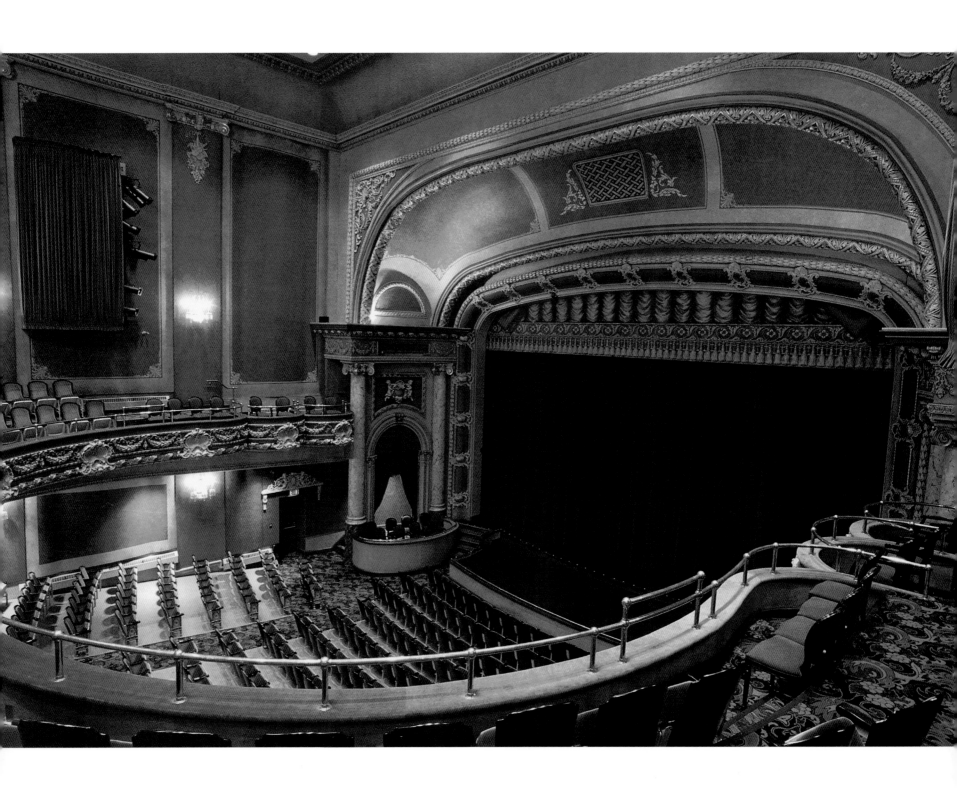

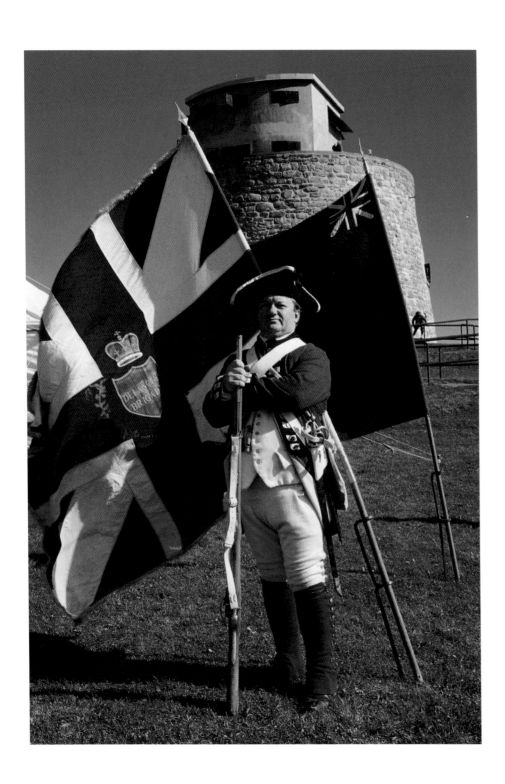

A member of Delancey's Brigade stands before the Royal and Regimental standards below Martello Tower, built during the War of 1812 overlooking the bay and harbour from the west. The brigade commemorates the nearly 2,300 Royal Provincial or Loyalist troops who entered the harbour in 1783 following the American Revolutionary War and their role in helping to found the province of New Brunswick.

Facing page: The majestic sweep of the Imperial Theatre's dress circle and proscenium arch greet the viewer from the balcony level. Built in 1913 facing King's Square, the theatre underwent extensive renovations and restoration from the 1980s to the early 1990s, transforming it into one of the best facilities of its type in Canada.

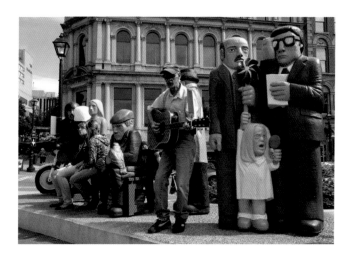

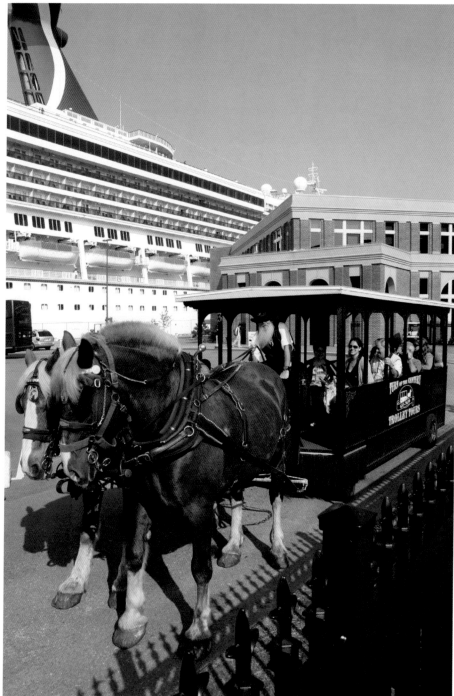

Above: A musician entertains passersby in front of John Hooper's "People Waiting" exhibit. Originally commissioned for a post office on the east side, its move to the uptown has been popular with tourists and local residents alike.

Cruise ship visitors take a horse tram ride with one of the city's two passenger terminals in the background. The busy summer and fall schedule has been a vital part of the city's economy in recent years. An important spinoff for local guides is the preparation of information on local history. Many more people now appreciate the place in which they live.

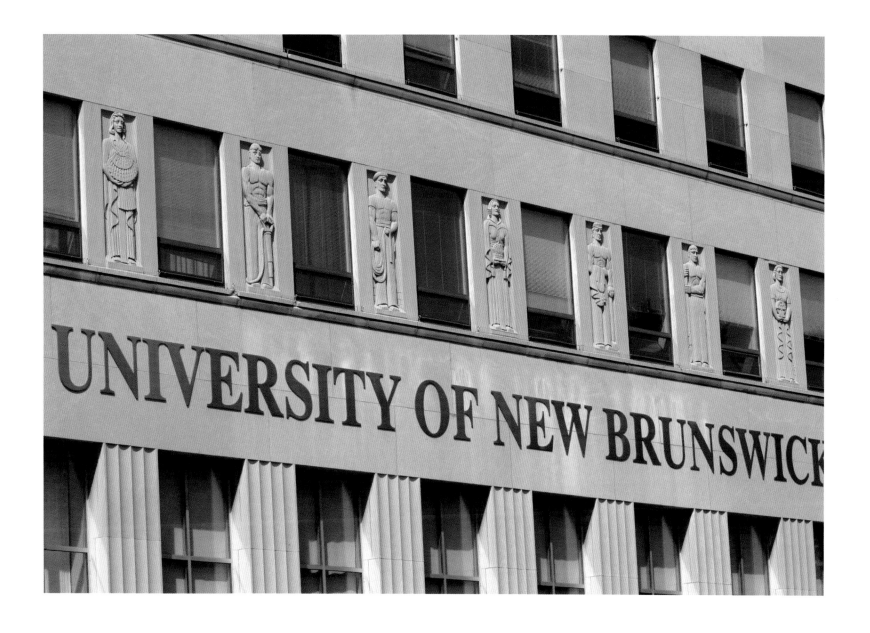

John Lyle of Toronto designed this 1939 bank building in the cool, restrained classicism of the period, decorating the second storey with panels of workers and their tools of the trade—the builders of the nation. The University of New Brunswick in Saint John assumed ownership of the building in 2006 after the bank left the site. The space was named the Grand Hall and has since been used for graduation receptions, weddings, public forums, presentations, and dinners. It gives the university a greater presence in the uptown area as well as a source of income from rentals.

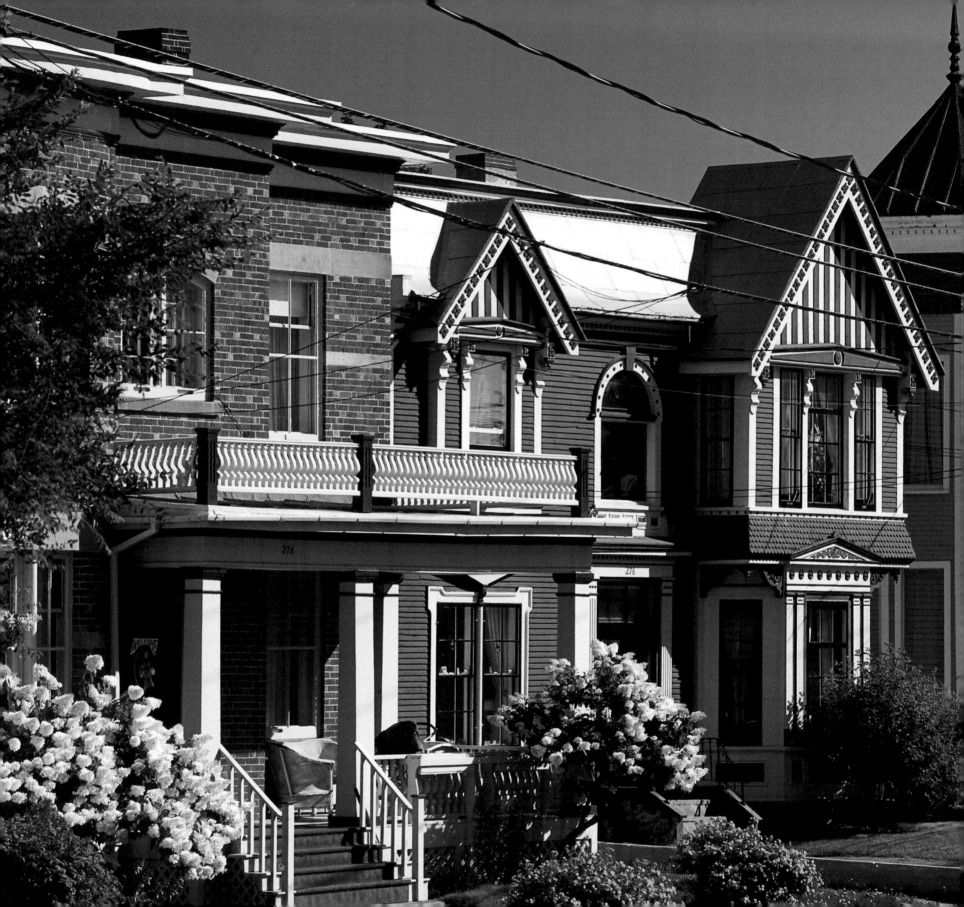

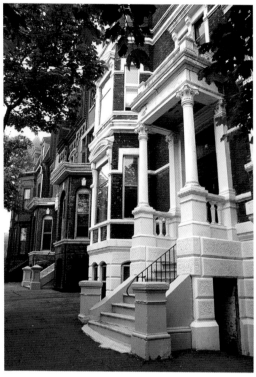

Above: Wide steps and a painted sandstone frontispiece form a welcoming entry to this red brick townhouse on Queen Square North in the south end of the city.

Douglas Avenue in the north end of the city began to develop quickly as a favoured suburban location after the electrification of the street railway system in the 1890s. These Queen Anne-style homes all date from that period.

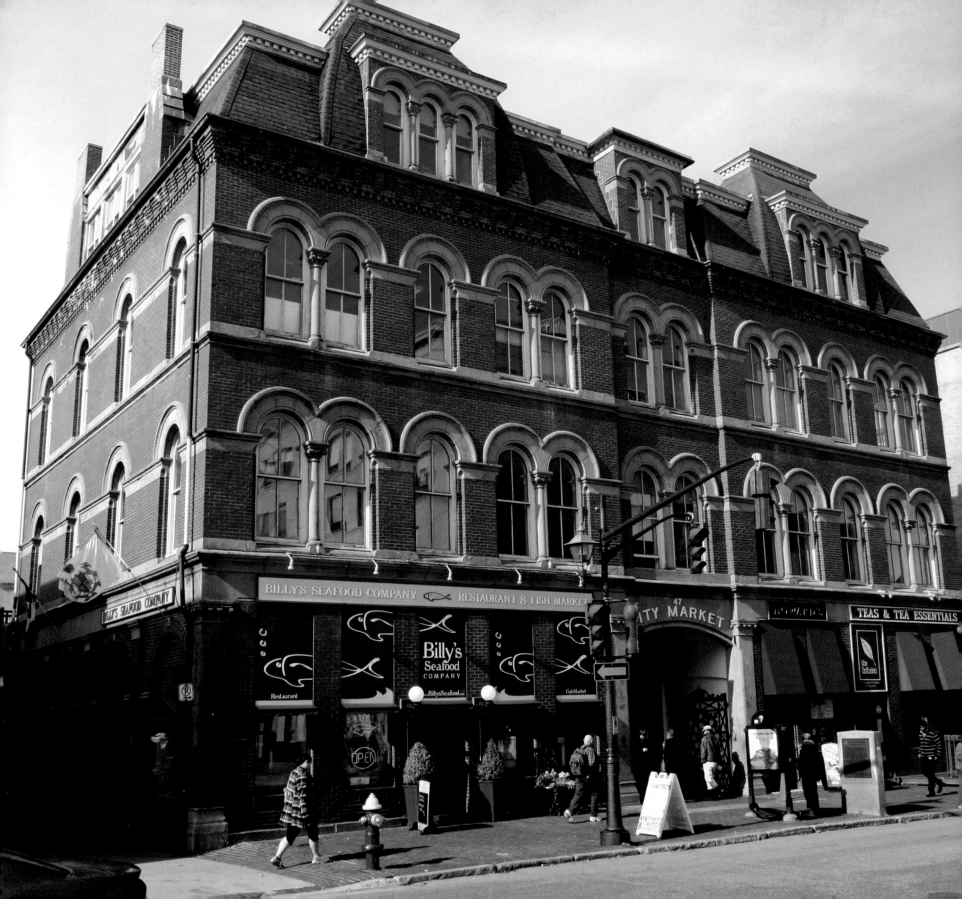

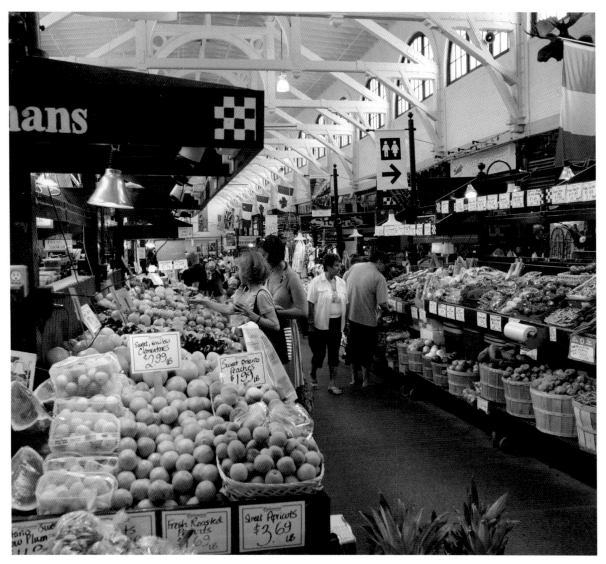

Above: Flowers enliven the historic lampposts in front of the old mercantile bank building at market slip.

Baleman's Produce looking down the centre aisle of Saint John's historic market built in 1876. The wooden trusswork supports a monitor roof for the admission of natural light. Railway passenger cars of the same period also used this structural approach.

Facing page: This Second Empire style block on Charlotte Street surrounds the eastern gates to the City Market at bottom centre. The market proper trails off in the left background. Designed by the Saint John architectural firm of McKean & Fairweather and finished in 1876, it survived the Great Fire the next year.

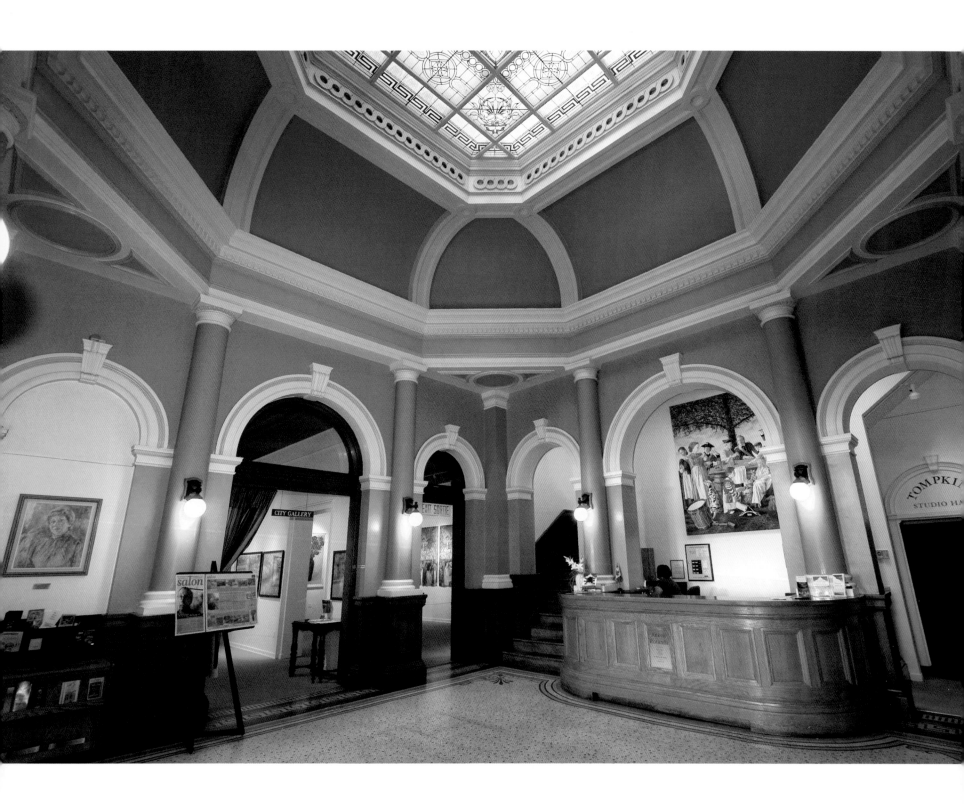

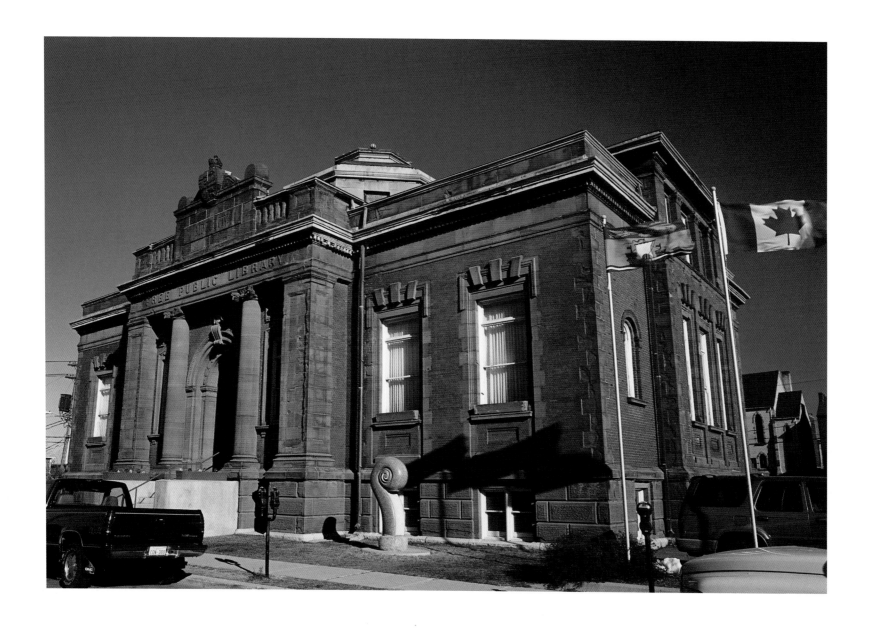

Originally built with assistance from the Carnegie Foundation, the Saint John Free Public Library opened its doors in 1904. This beaux-arts style building on Hazen Avenue now houses the Saint John Arts Centre.

Facing page: The atrium of the Saint John Arts Centre features Roman Doric columns under a vaulted skylight amidst vivid colours. Originally the Saint John Free Public Library built on Hazen Avenue in 1904, the centre has operated as a gathering place for exhibitions, performances, and community events since the mid-1980s.

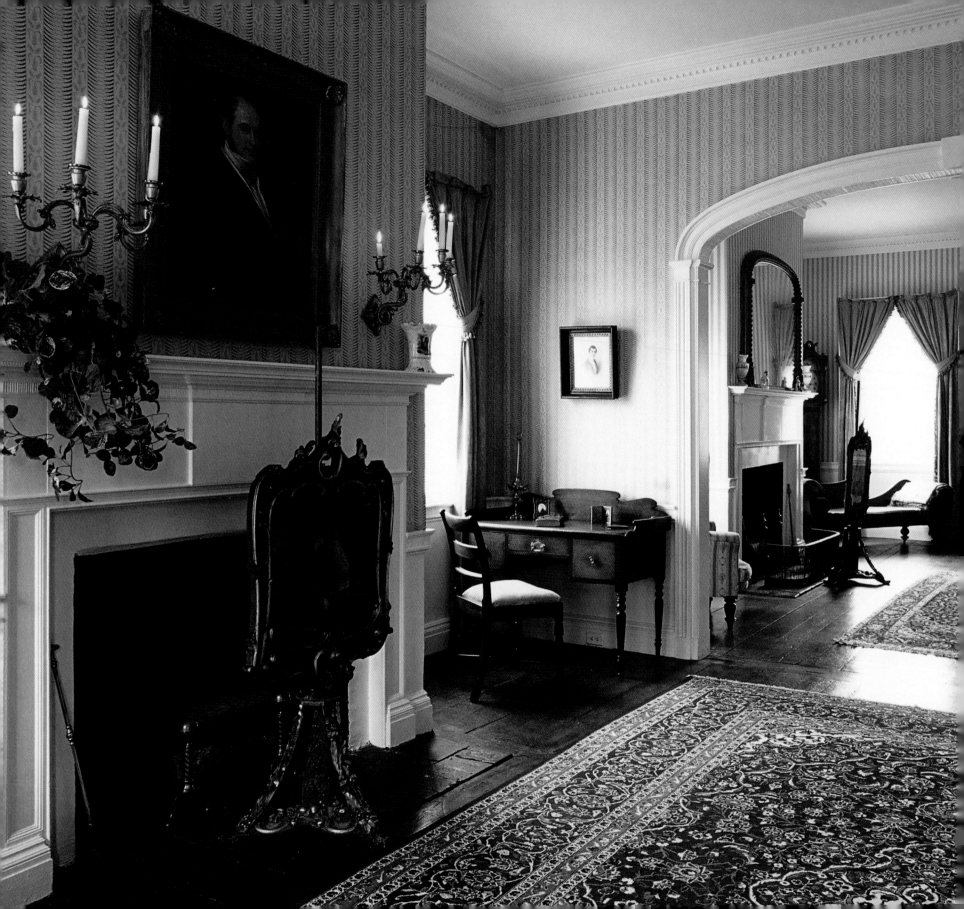

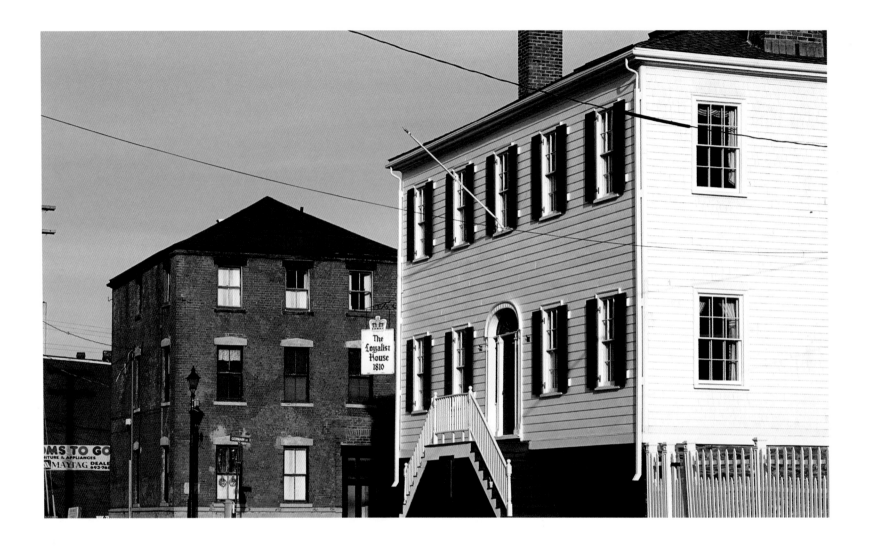

The white clapboards of Loyalist House (1810) on Union Street dominate the eye but cannot eclipse the city's oldest brick building (1819) in the background.

Facing page: An internal view in Loyalist House, owned and operated by the New Brunswick Historical Society. The displays of material culture seek to represent the Merritt family's life in early Saint John in the years following their departure from Long Island, New York, at the close of the American Revolution in 1783.

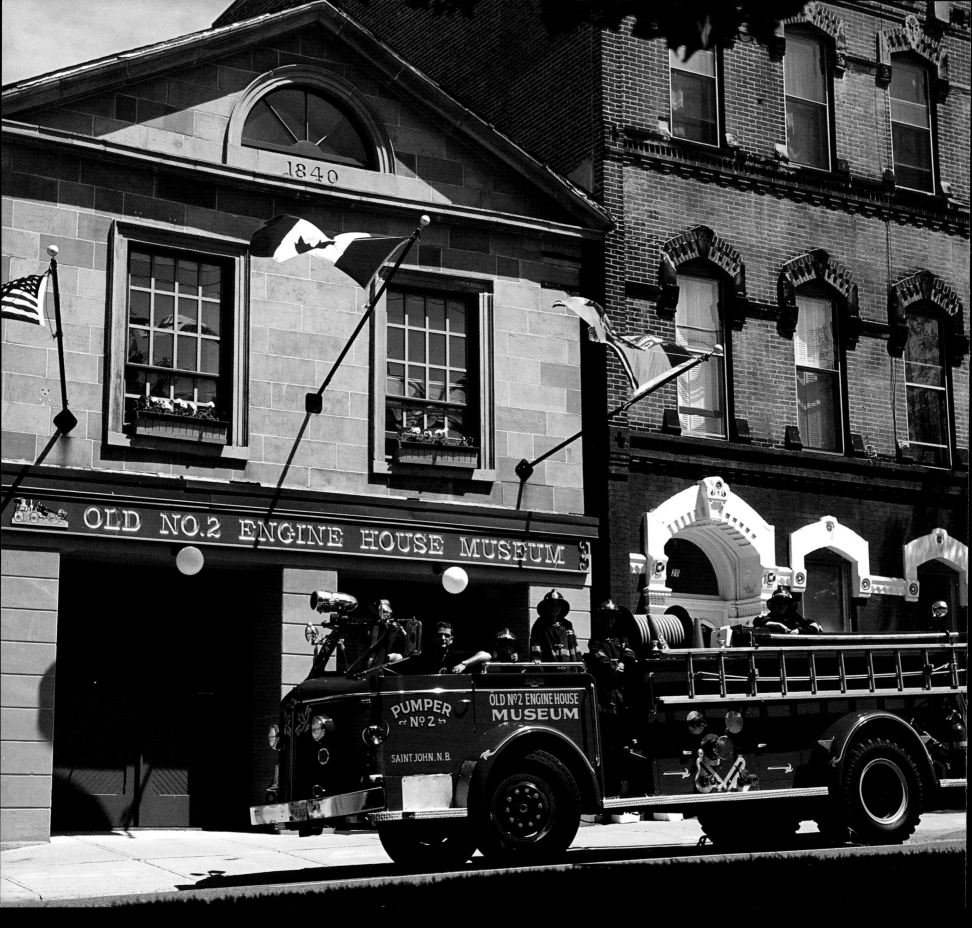

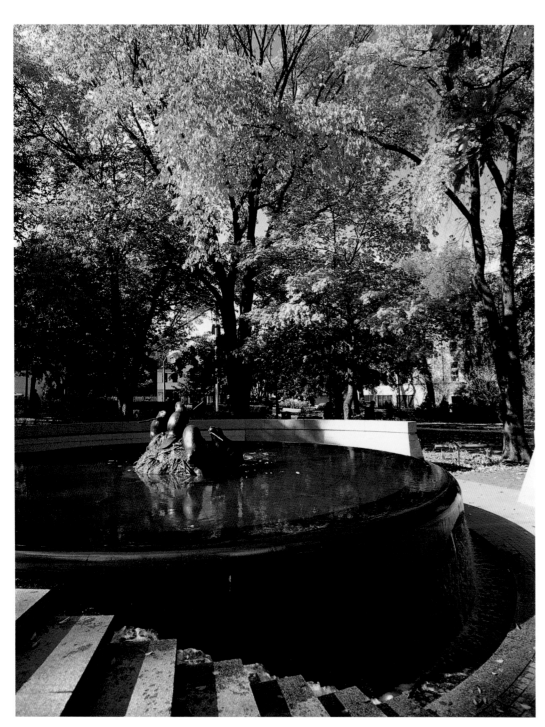

Fall colours form a backdrop for the cascading fountain in the Loyalist Burial Ground. The sculpture of the beavers at work was done by world-renowned British sculptor Michael Rizzello in 1995.

Facing page: Built in 1840, No. 2 Engine House is the oldest building of its type in Canada. It is now a popular firefighting museum facing King's Square in the heart of the city. The building's importance has resulted in its designation as a National Historic Site.

Graceful brick housing strikes a comfortable posture on Germain Street in the heart of the city. In the foreground is "Carleton House," originally the home of New Brunswick premier, lieutenant-governor, and Father of Confederation, Sir Samuel Leonard Tilley. The house was designed by Saint John architect H.H. Mott and finished in 1888.

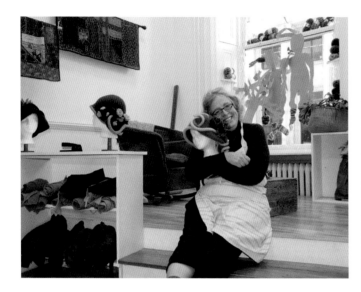

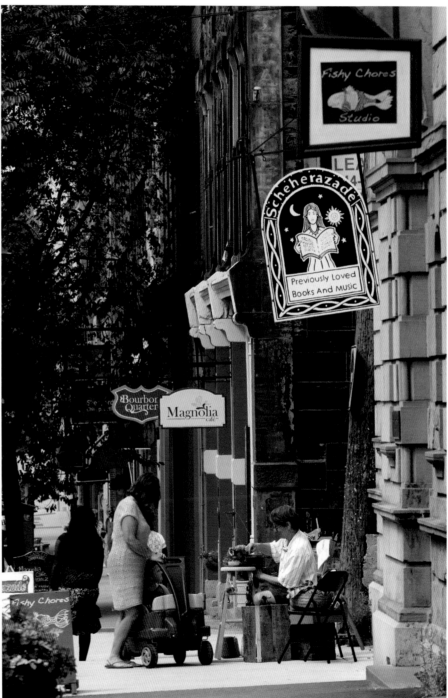

Above: Dafne Mildenberger's Fishy Chores shop on Prince William Street features felt hats, hand-knit socks and silk batiks. Here the artist embraces one of her creations.

A visitor with a toddler stops outside the Fishy Chores shop on Prince William Street to take in a sock-knitting demonstration. Hand-knit socks are featured inside.

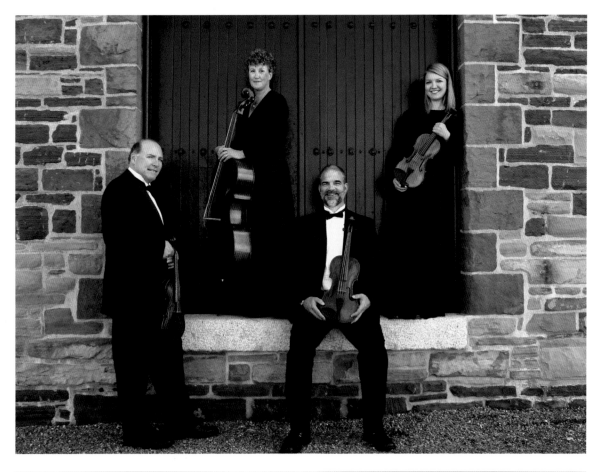

Above: The Saint John String Quartet poses in a doorway of the recently restored Ordnance Building in the city's south end.

This view from West Saint John features St. George's Anglican Church. Dating from 1821, it is the city's oldest church but has certainly undergone alterations during its history. Originally a classical structure, it now sports a tower with castellated Gothic accents. Three cruise ships fill the harbour in the background.

Facing page: Trinity Anglican Church photographed at night with the Sunday School and office elevation on Charlotte Street in the foreground and the church proper with steeple facing Germain Street in the background. The church was designed in the High Victorian style by Montreal architect W.T. Thomas after the Great Fire and opened in December of 1880.

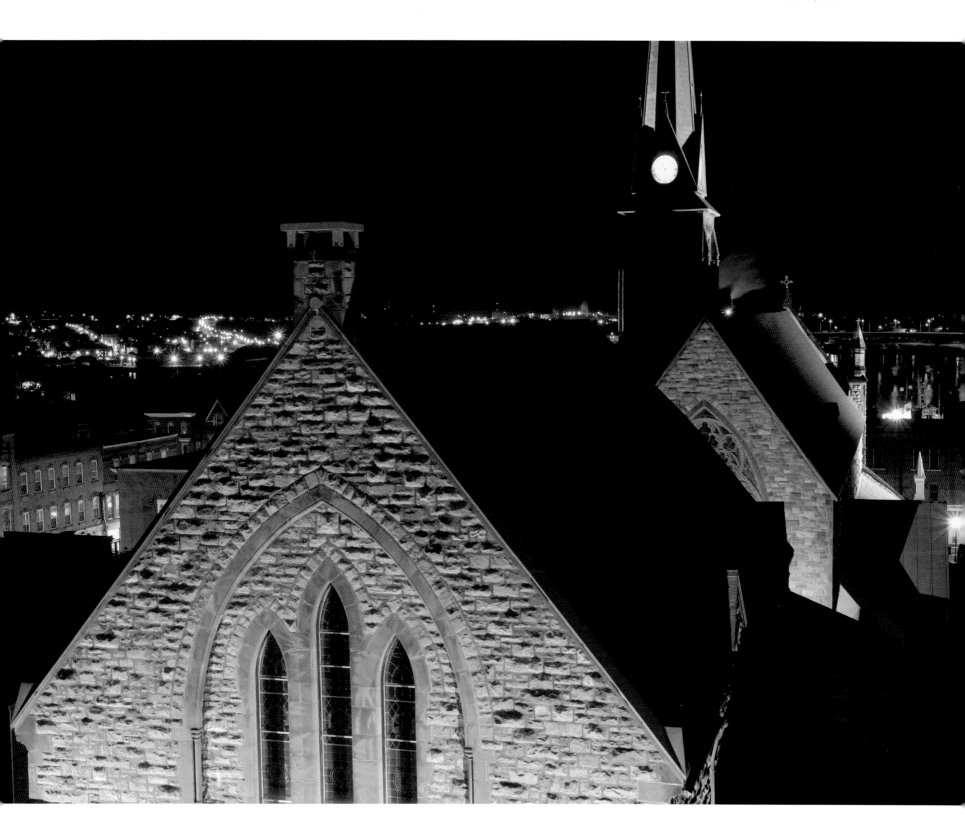

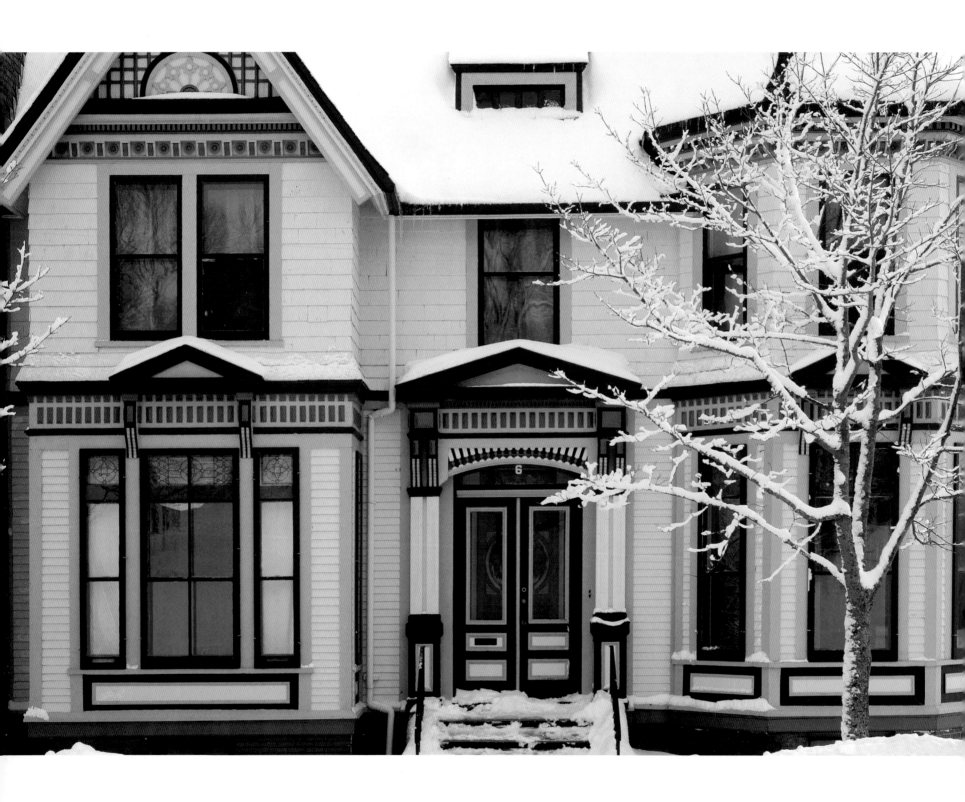

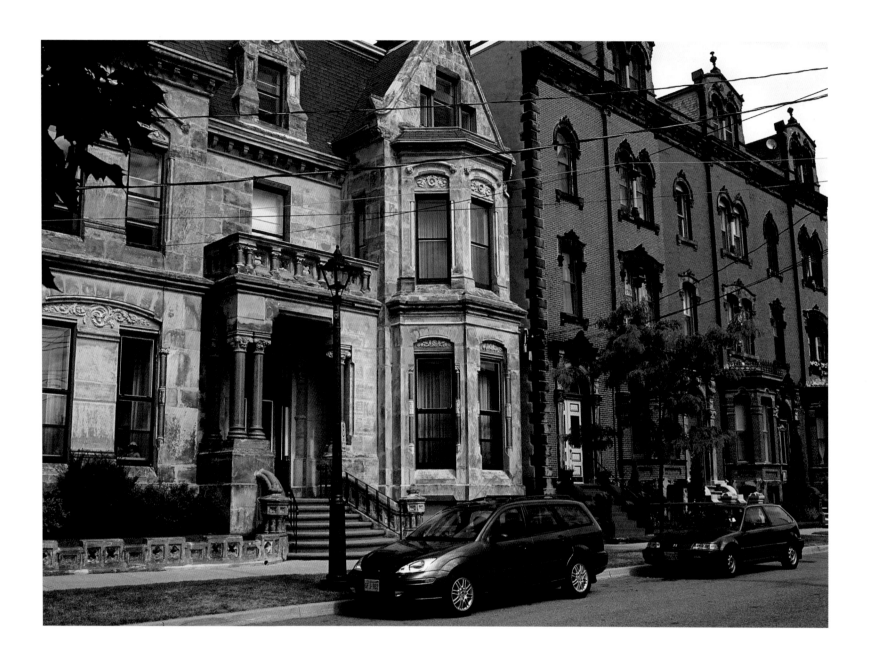

Late nineteenth-century buildings on Orange Street, built of contrasting materials. The stone house with Renaissance chateau accents at left is credited to the local architectural partnership of Dunham & Clarke.

Facing page: Snow caps the roof and architectural features on this brightly painted Queen Anne-style residence on Queen Square in the city's south end.

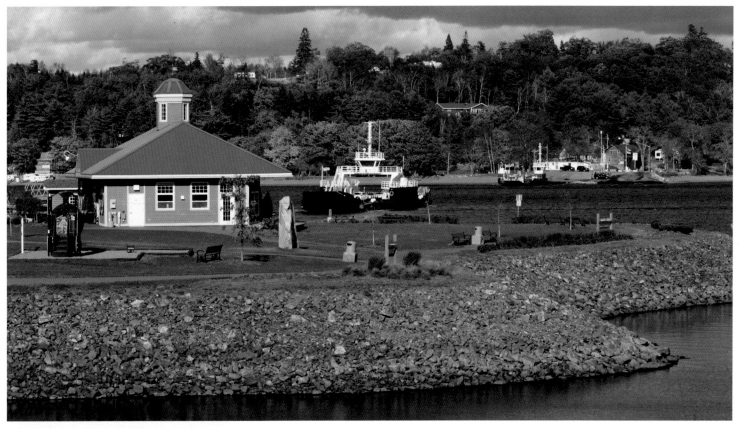

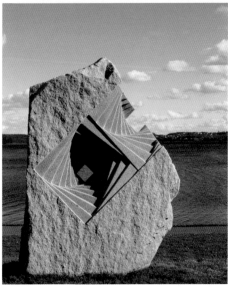

Above: The Brundage River Centre at Grand Bay-Westfield north of the city forms a new landmark on the Westfield ferry run to the Kingston Peninsula in the background. It joins the Loyalist-era Harding house with green roof standing guard in the distance.

An untitled sculpture in granite by Bulgarian stone carver Radoslav Sultov dominates the sweep of the lower St. John River from its vantage point on the grounds of the Brundage Point River Centre. It was created as part of the International Sculpture Symposium organized by Sculpture Saint John. Six sculptors from around the globe were given six weeks to create a work of art from mammoth chunks of granite. All activity took place between early August and mid-September in the uptown area on the Ministry of Transport Wharf. The finished pieces were purchased by communities within the region.

Facing page: Well-known Saint John artist Gerald Collins at work in his studio camp on the shore of a lake off the Golden Grove Road on the eastern outskirts of the city.

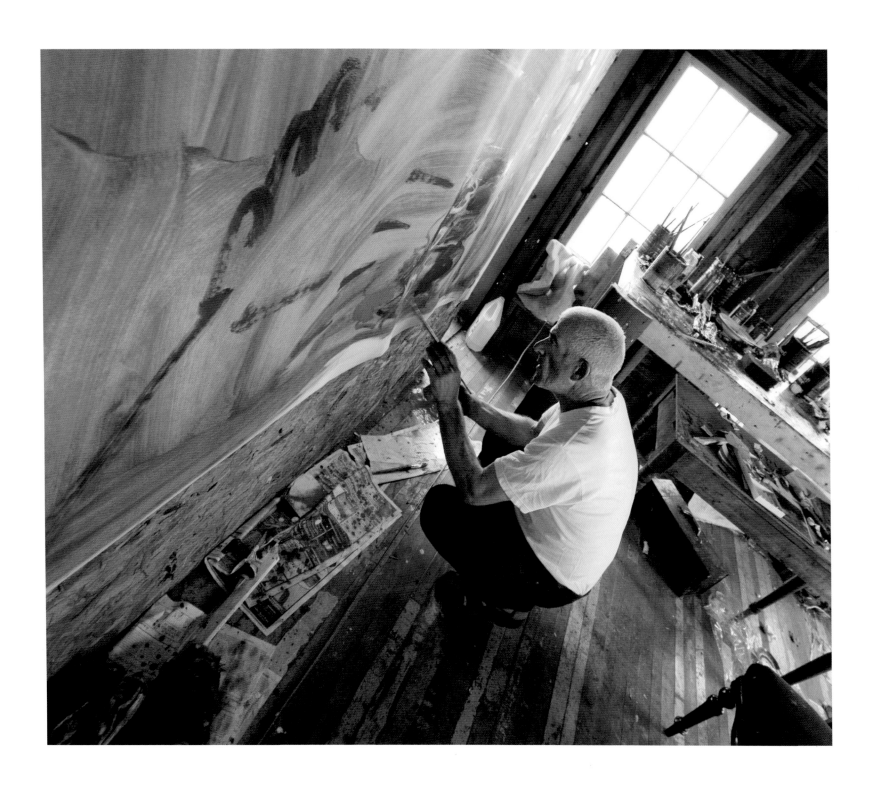

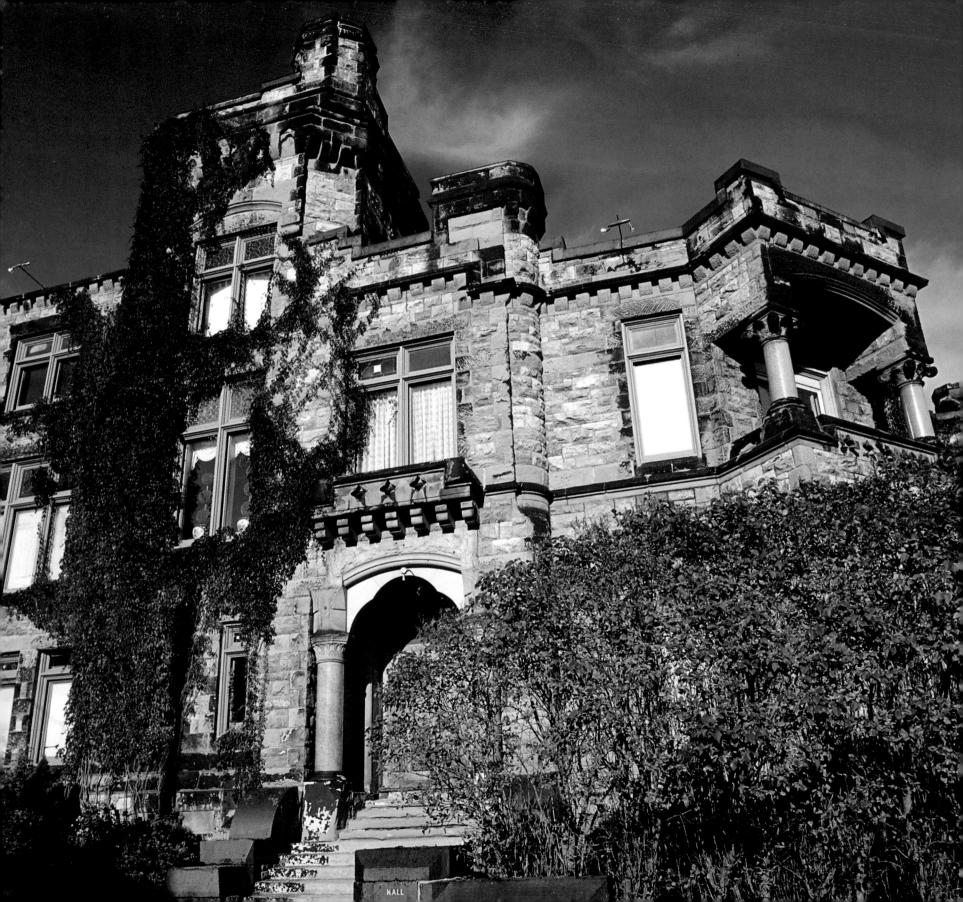

HALL

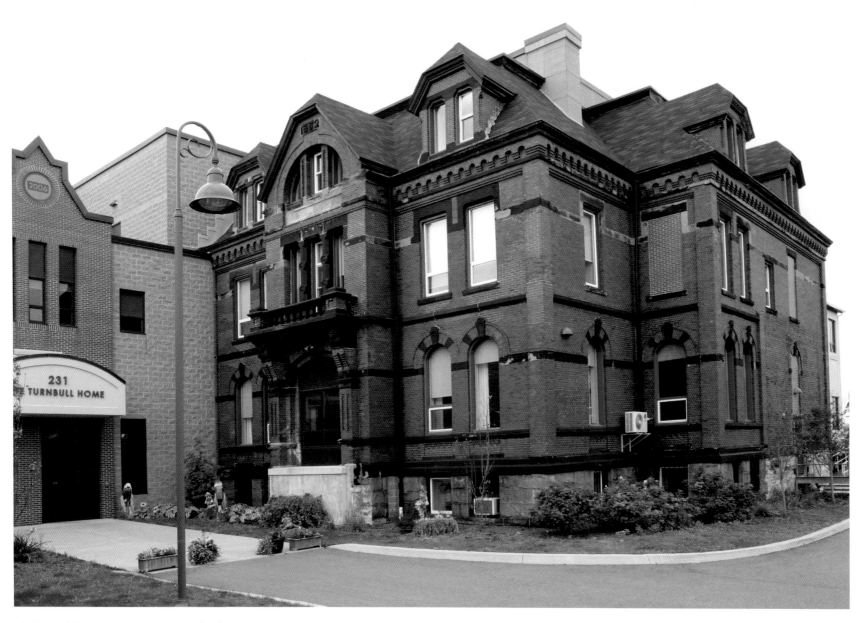

The Turnbull Nursing Home in the city's south end was originally a hospital for sick and disabled mariners. Designed by Saint John architect David Dunham to federal specifications in 1882, the building presents an interesting mixture of styles ranging from the Italianate to Romanesque. A new extension was added in 2006.

Facing page: Caverhill Hall on Sydney Street in the south end was completed in 1881 by a Toronto architect for Simeon Jones, a brewer and mayor of the city.

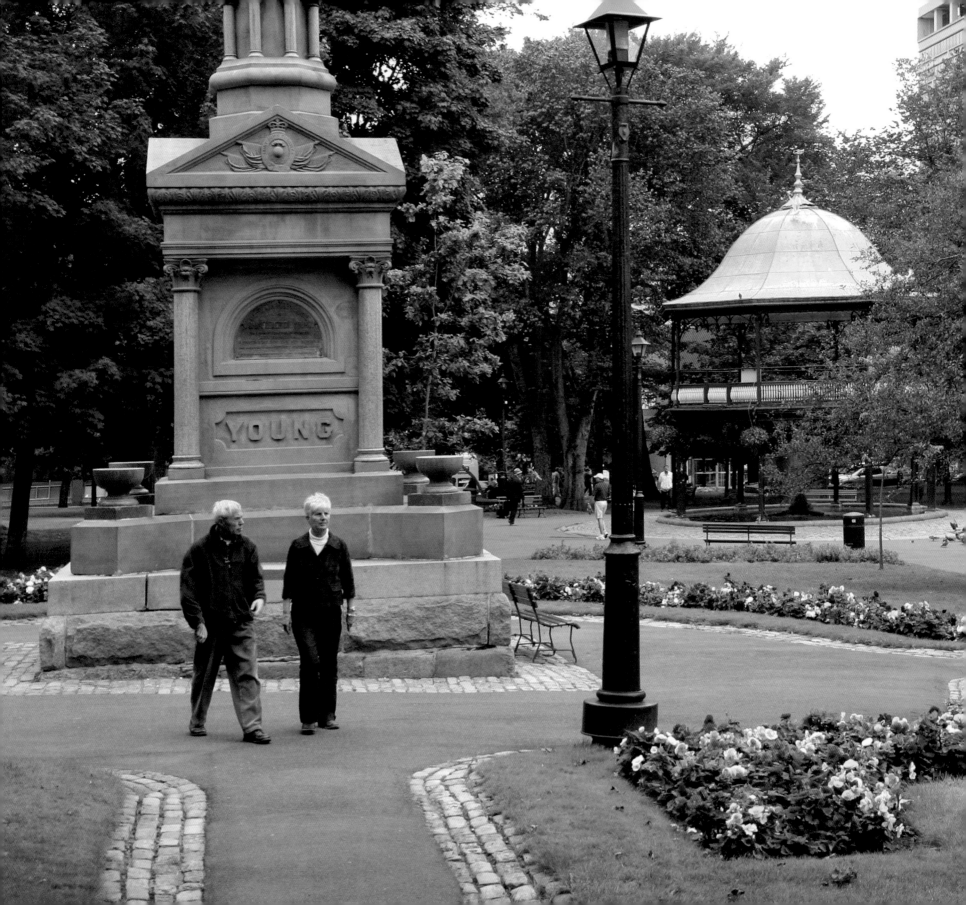

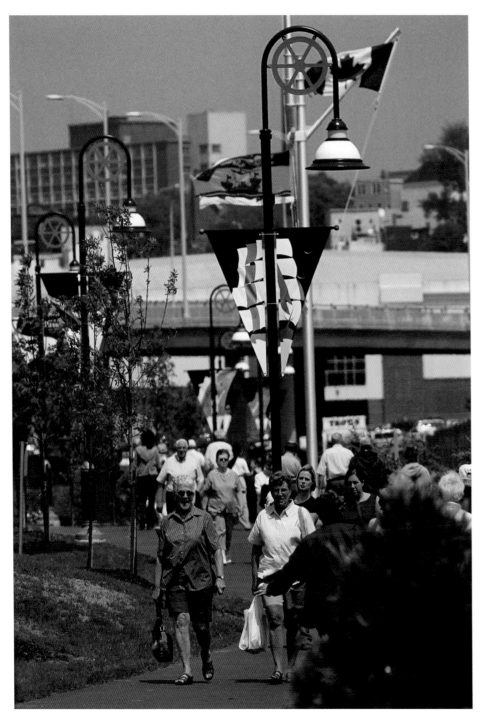

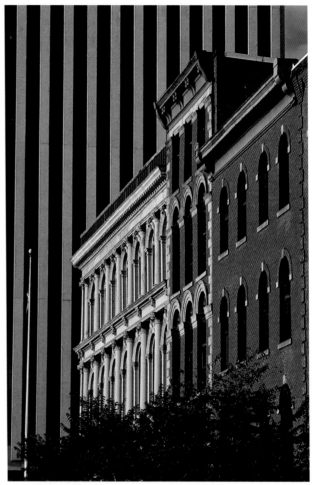

Above: Twentieth-century architecture provides a simplified background for these heritage buildings on Prince William Street.

Tourists and local citizens alike have flocked to the Harbour Passage walkway since its opening in the summer of 2003. The Harbour Station entertainment complex can be seen in the background.

Facing page: The Young Memorial in King's Square was erected in 1891 in memory of Fred Young who lost his life while attempting to save a friend from drowning.

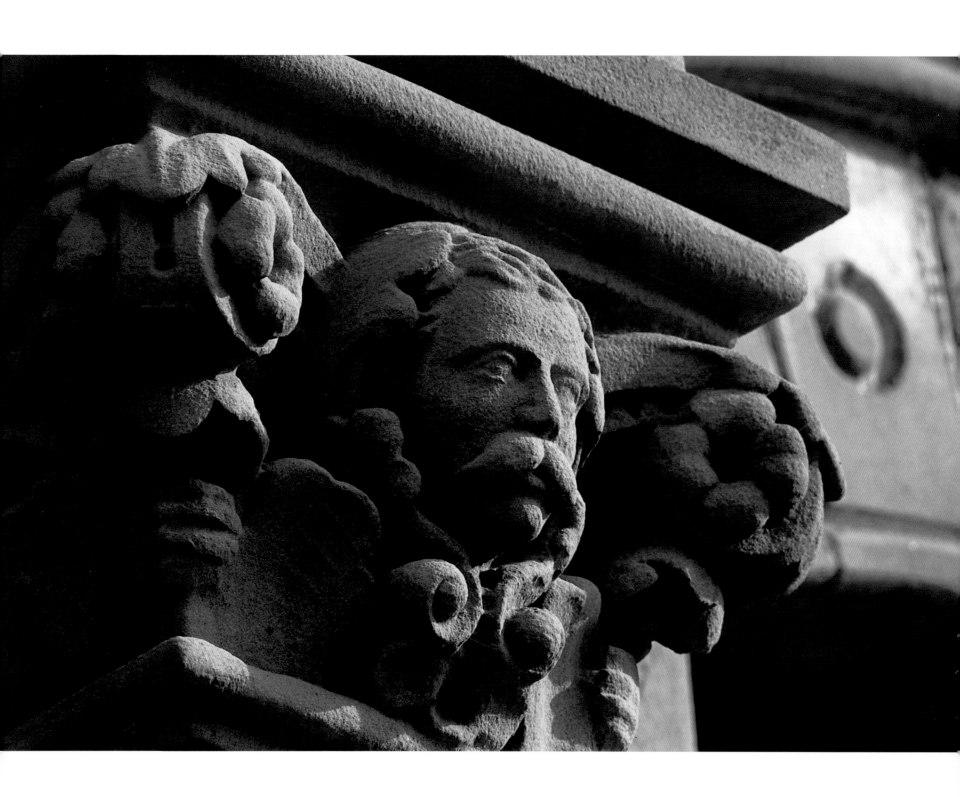

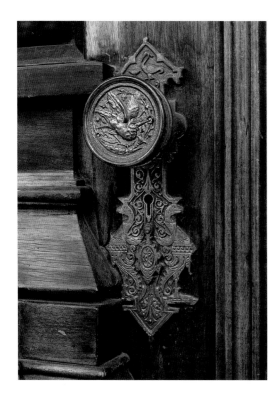

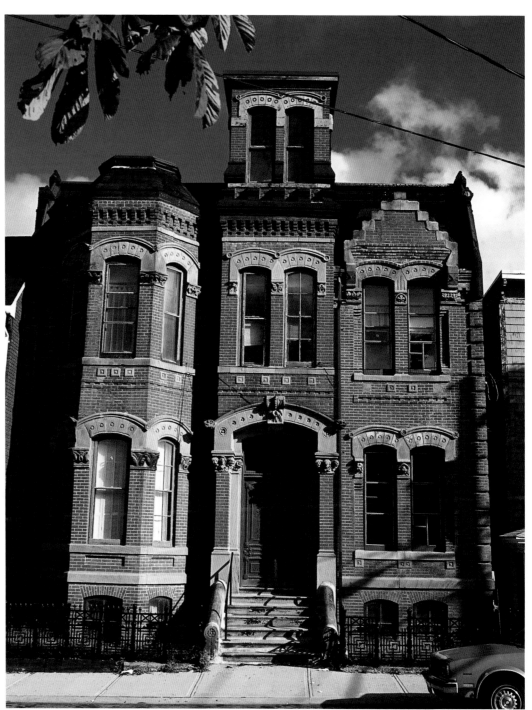

Above: An ornate doorknob adorns a Germain Street residence.

A close inspection of this Hazen Street house reveals sculptural characterizations of a man (facing page) and woman gracing the pilaster capitals on either side of the door surround. These no doubt represent the first couple in their new home, about 1875.

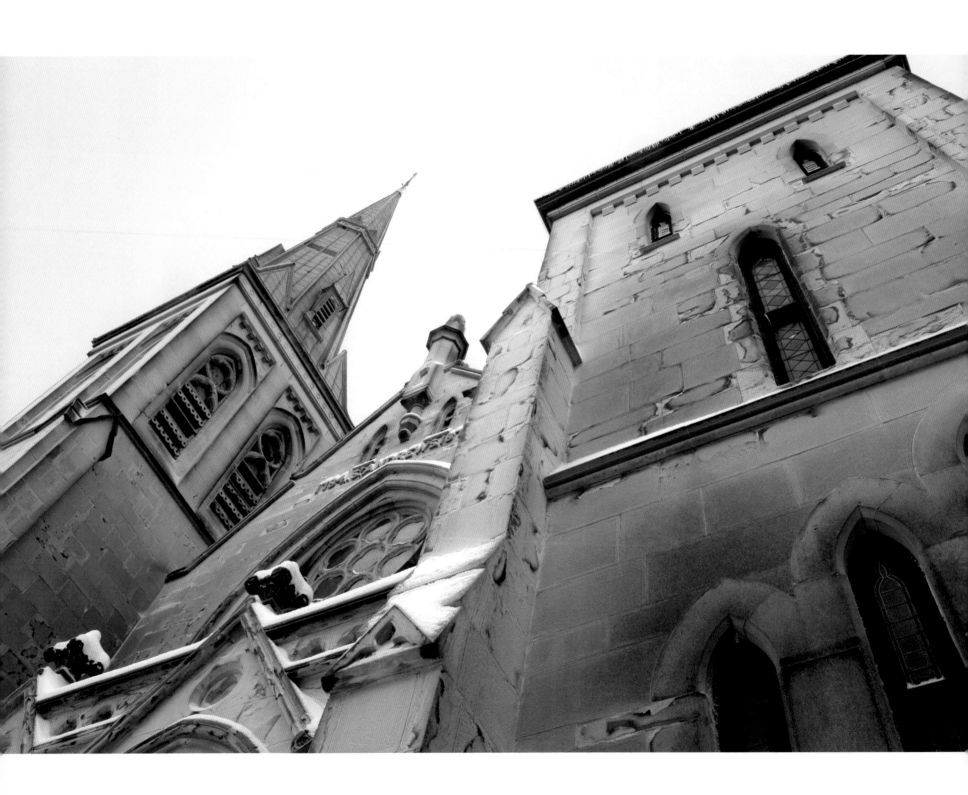

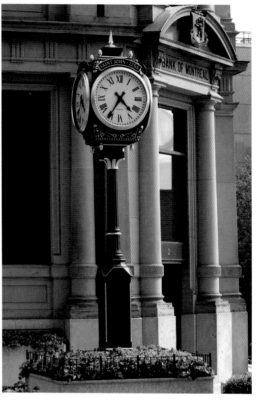

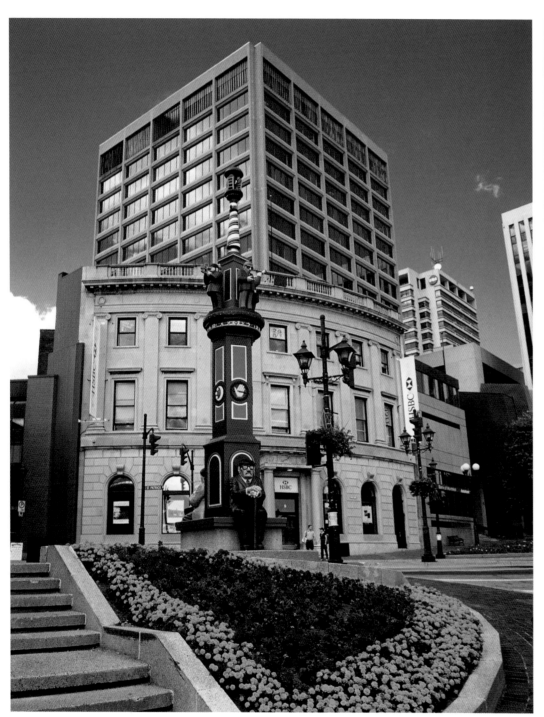

Above: This elegant public timepiece was commissioned to mark the city's 225th anniversary in 2010. It stands at the foot of King Street near the corner of Prince William.

"Timepiece" (1983), a magical working clock by John Hooper and Jack Massey, sprouts from a bed of flowers in the city's downtown Market Square district. The curved elevation of the original Bank of British North America (c.1914) becomes a pleasing backdrop for this unusual piece of art and technology.

Facing page: A hoary frost covers the front elevation of St. Andrews & St. David's United Church on Germain Street. Built to a design by the Toronto architectural firm of Langley, Langley & Burke after the Great Fire of 1877, it has recently begun to share services with Centenary Queen Square United Church.

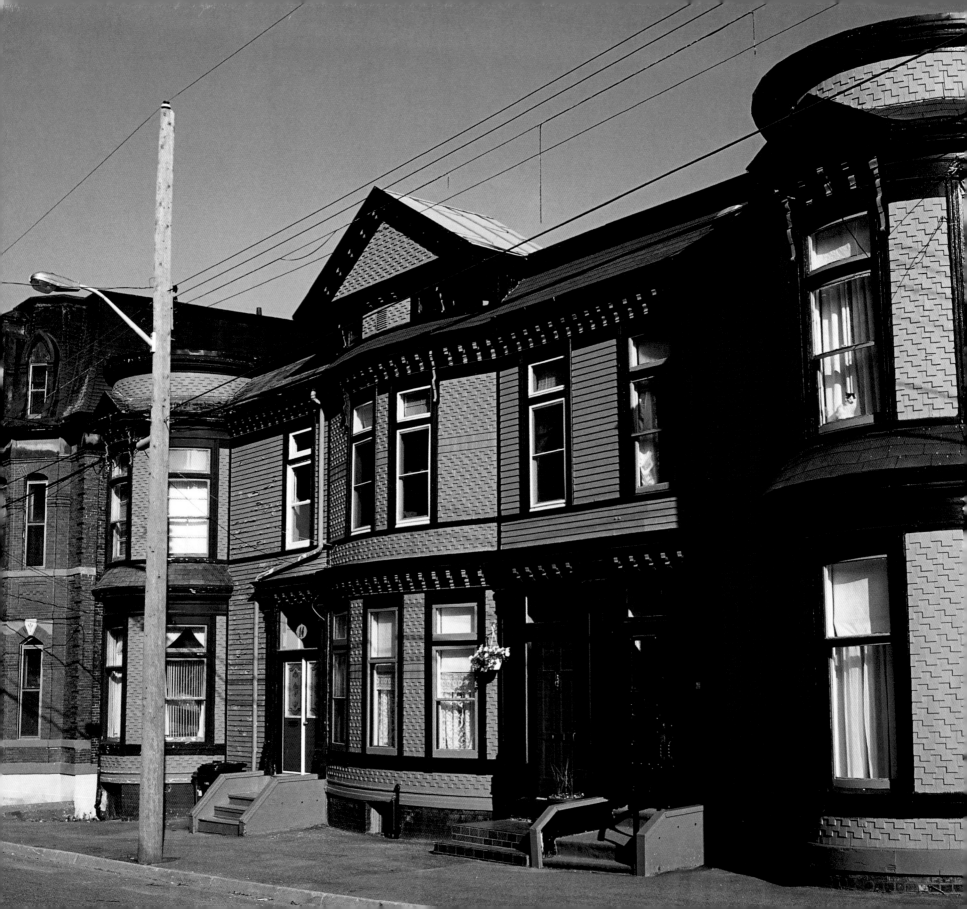

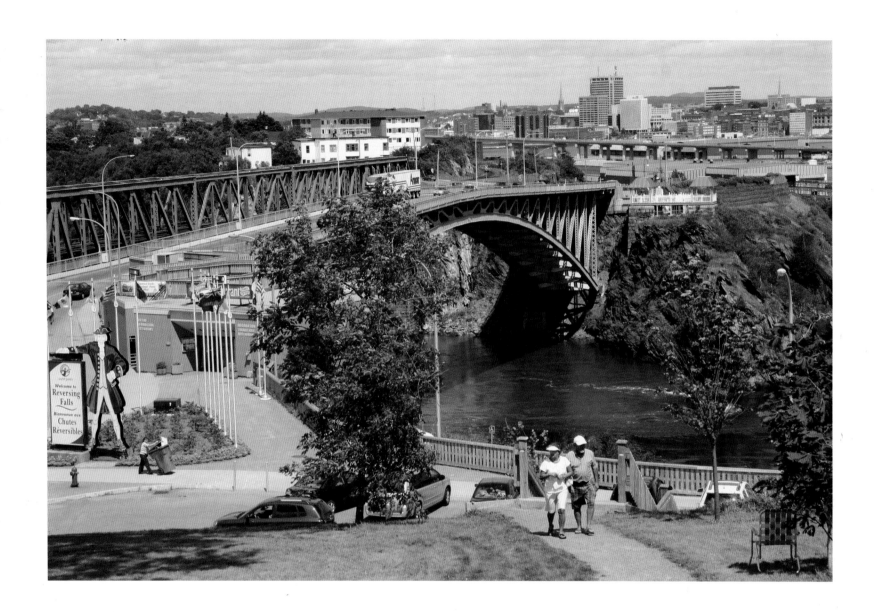

This was a favourite vantage point for Saint John photographers during the nineteenth century since it featured rail and road bridges over the Reversing Falls gorge with the city centre in the background. The first road crossing was via a suspension bridge in 1853. A new interpretation lookout on the opposite side recounts the history of the bridges through photographs and captions.

Facing page: Patterned shingles, tower pavilions, a central pediment, and a bright red door greet the viewer from this Queen Anne-styled apartment complex in the south end.

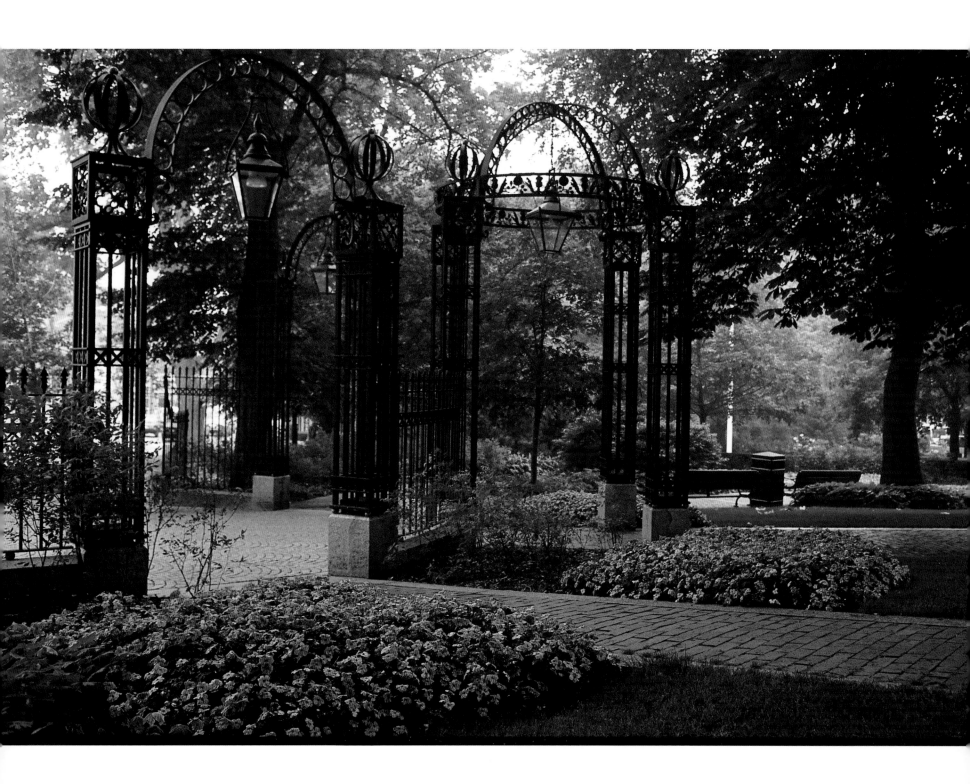

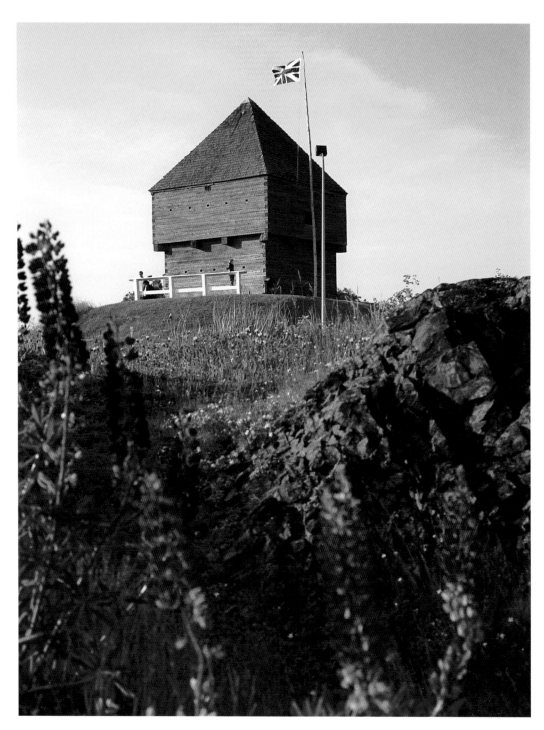

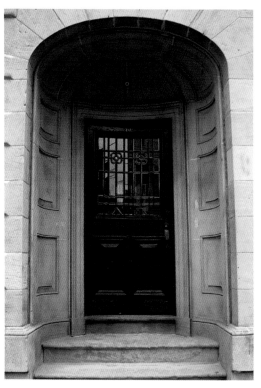

Above: When is a doorway more than a doorway? This wonderful example of paneled geometry is surely the highlight of a neo-classical sandstone building on Coburg Street attributed to Saint John architect John Cunningham. It was built circa 1830.

This blockhouse from Canada's centennial year of 1967 commemorates an original structure on the spot that formed part of the Fort Howe complex, established in 1777. Designed to combat rebel privateers and other irregular forces during the American Revolution, the fort discouraged enemy activity from its commanding position overlooking the harbour.

Facing page: The main gate of the Loyalist Burial Ground next to King's Square welcomes visitors tracing their ancestors. Laid out in 1784 on the edge of the new community, it closed in 1848 and became a memorial garden with trees, flowers and walkways. In the early 1990s, the Irving family commissioned British landscape architect Alex Novell to design a major refurbishment of the entire site as a gift to the city and its people. Work began in 1994 and was completed the next year.

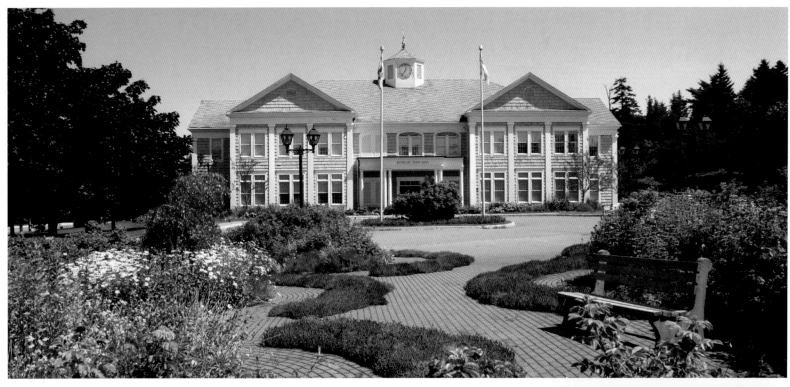

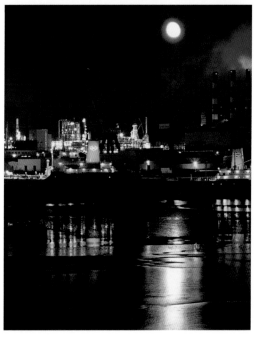

Above: Rothesay Town Hall, designed by Saint John architect Tom Johnson in 1991. The symmetrical massing and cupola gives the composition a timeless, classical feel.

Across the Courtenay Bay flats, two oil tankers, the Irving Oil Refinery, and a power plant form their own city lights under a full moon.

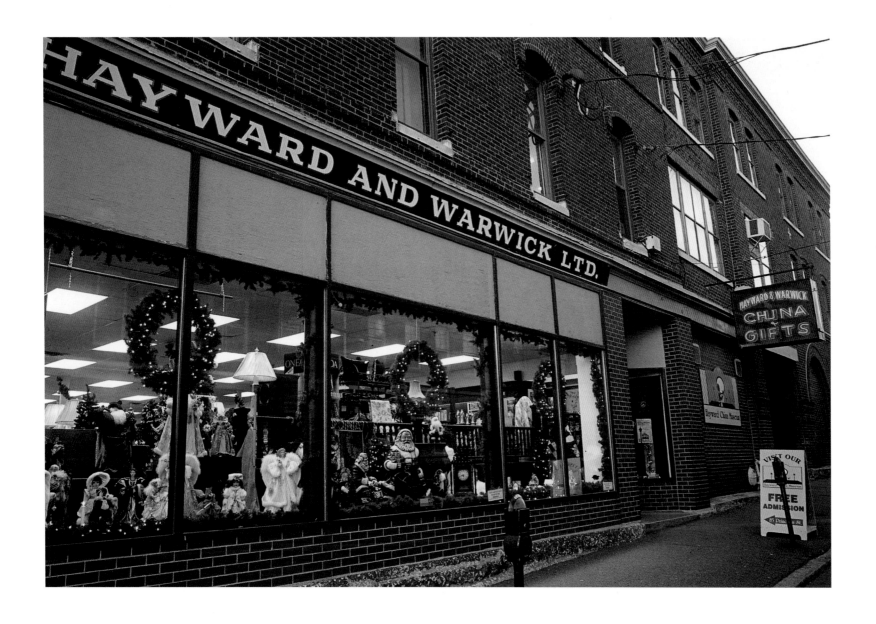

Hayward and Warwick Ltd. have based their retail operation on fine china and glassware since the store's founding on Prince William Street in 1855. When the Great Fire of 1877 destroyed the shop, the owners quickly had more spacious premises rebuilt on Princess Street, the shop's location to this day.

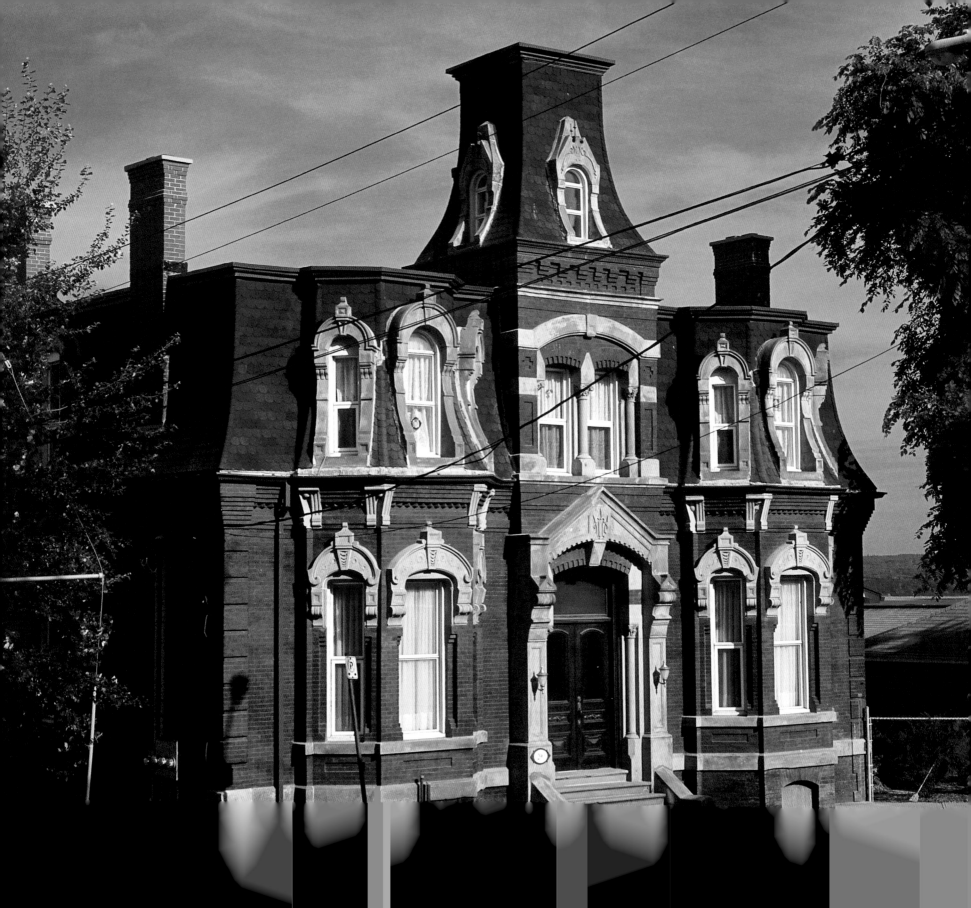

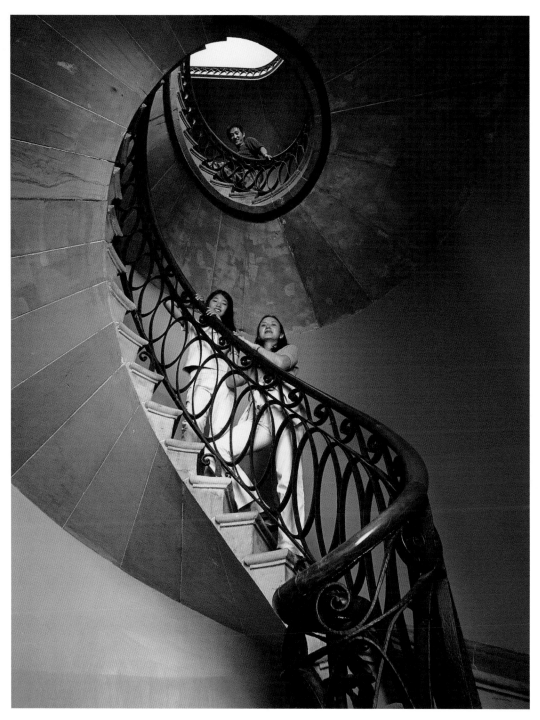

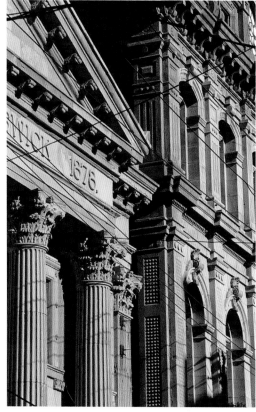

Above: The Stone architecture bravely weathers the passage of time in the city's heritage preservation area.

Scottish immigrant and architect John Cunningham designed this spiral staircase in his neo-classical Saint John County Courthouse, completed in 1830. It remains a must-see tourist attraction.

Facing page: "Cottage" seems too modest a description for this ornate, Second Empire-styled structure, with its treed lot, on Crown Street. It was once the home of harbour industrialist C.N. Wilson.

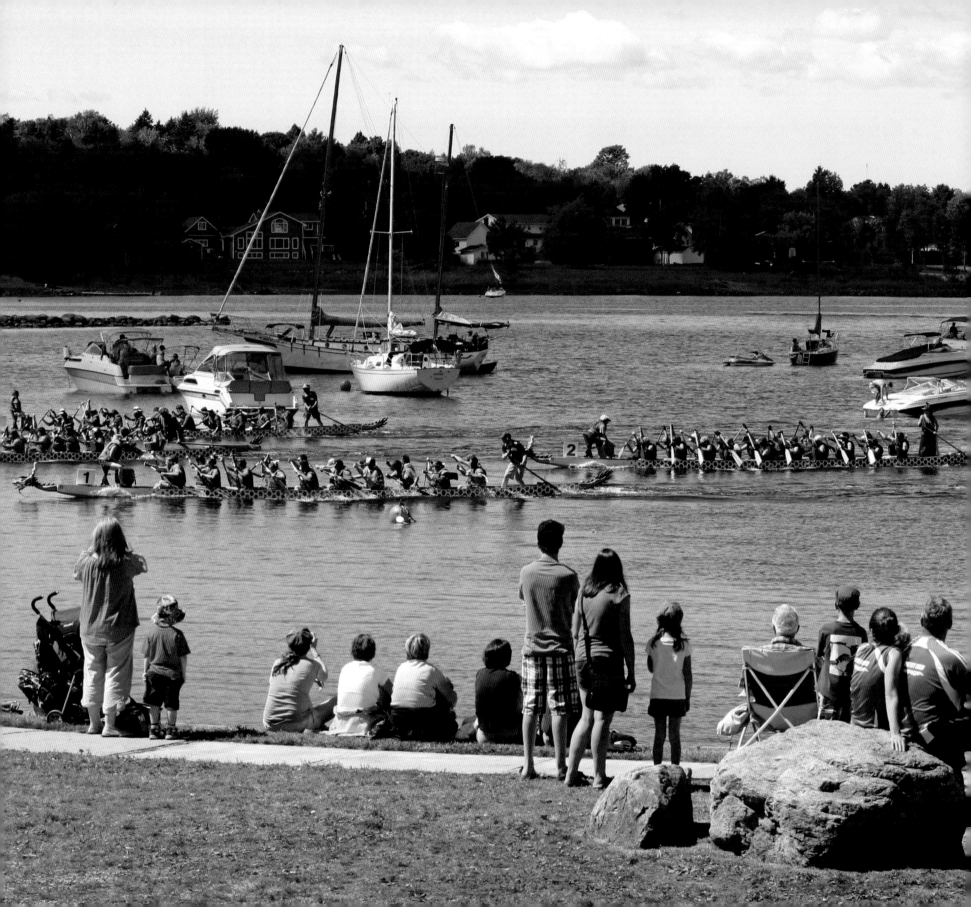

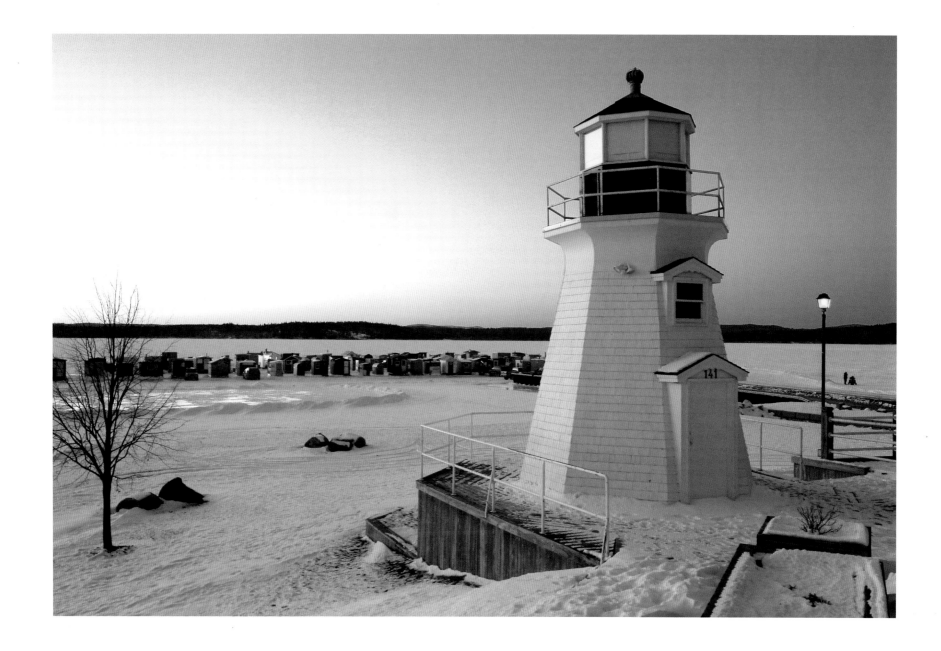

It takes a smelt to raise a village! Ice fishing shacks huddle against the cold in gathering dusk at Renforth. Every year ice fishing nomads descend on this stretch of river to catch smelt, waiting patiently in heated comfort with their lines through holes in the ice.

Facing page: Dragon boat races near the Renforth Wharf combine fun with a serious purpose by raising funds for the St. Joseph's Hospital Foundation.

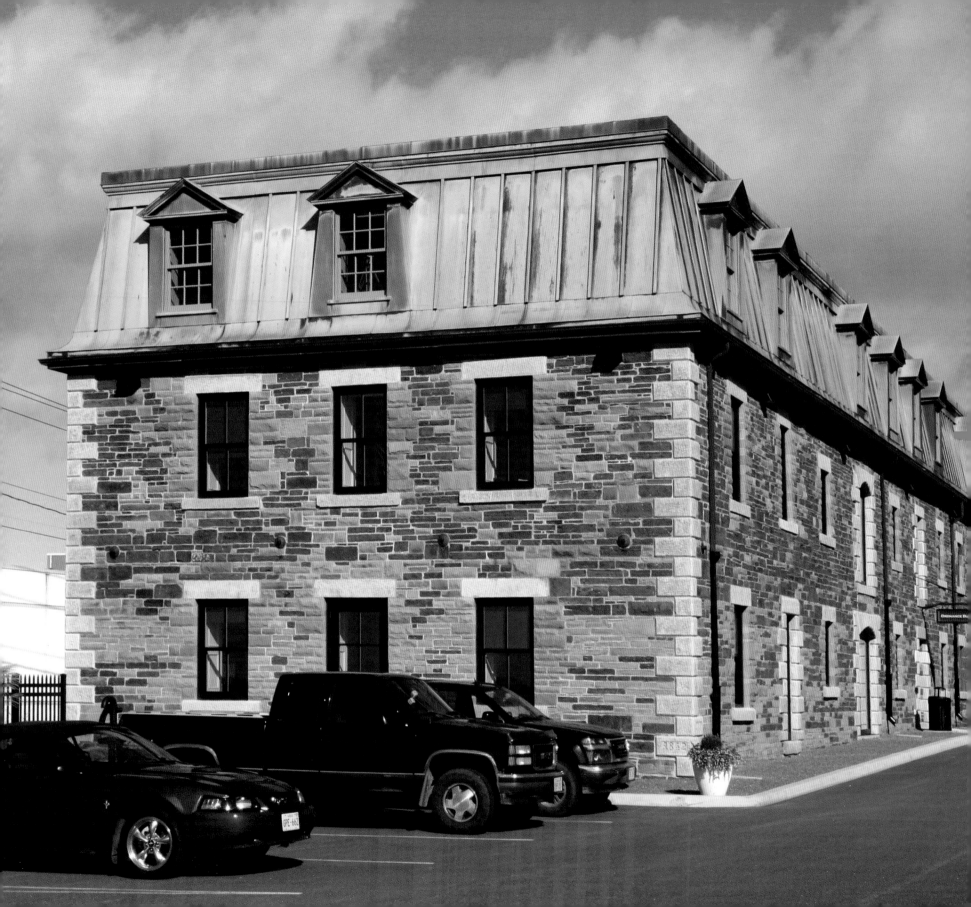

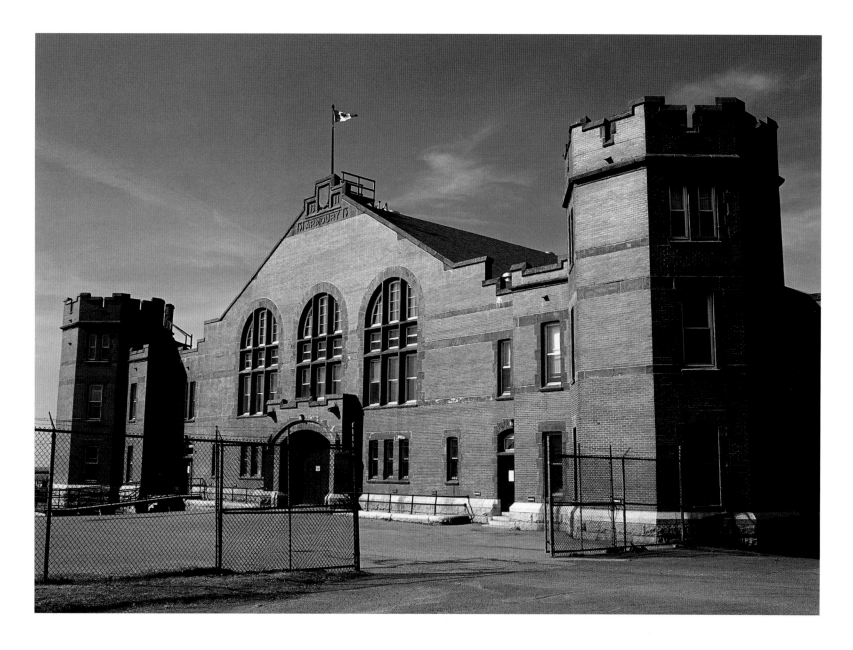

The Saint John Armoury near the harbour at the end of the city's main peninsula was completed in 1911 as part of an expansion of the federal Militia Department's building program in Canada in the years before the First World War. It maintains a Canadian Army presence in the city to this day.

Facing page: Designed and built in 1841–42 as part of the British Army's establishment in Saint John, the Ordnance Building originally had a pitch roof with dormers. The Great Fire of 1877 destroyed the roof, but the walls remained standing. In 1911, with the construction of the Saint John Armoury next door, the Ordnance Building received a new mansard roof. Recently the building was acquired by Commercial Properties Ltd. and its exterior and interior were rehabilitated. It remains the only structural reminder of the Imperial Army in the city.

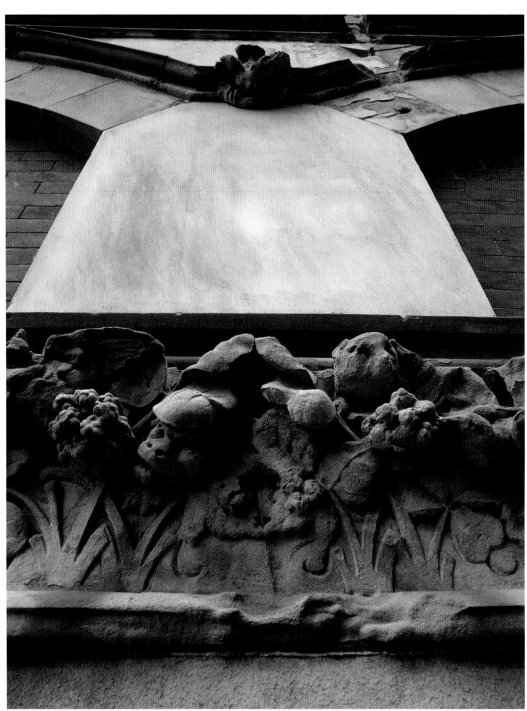

Above: Iron fencing on Germain Street presents a woven geometric pattern against grey stone and red brick.

Sculptural motifs of birds, animals and plants provide intriguing decor to many facades in the heritage district.

Facing page: Described as "blocks," these three brick office structures on King Street are typical of the kind of simultaneous development that occurred after the Great Saint John Fire of 1877. Owners preferred blocks of buildings so that one or another structure did not dominate the skyline.

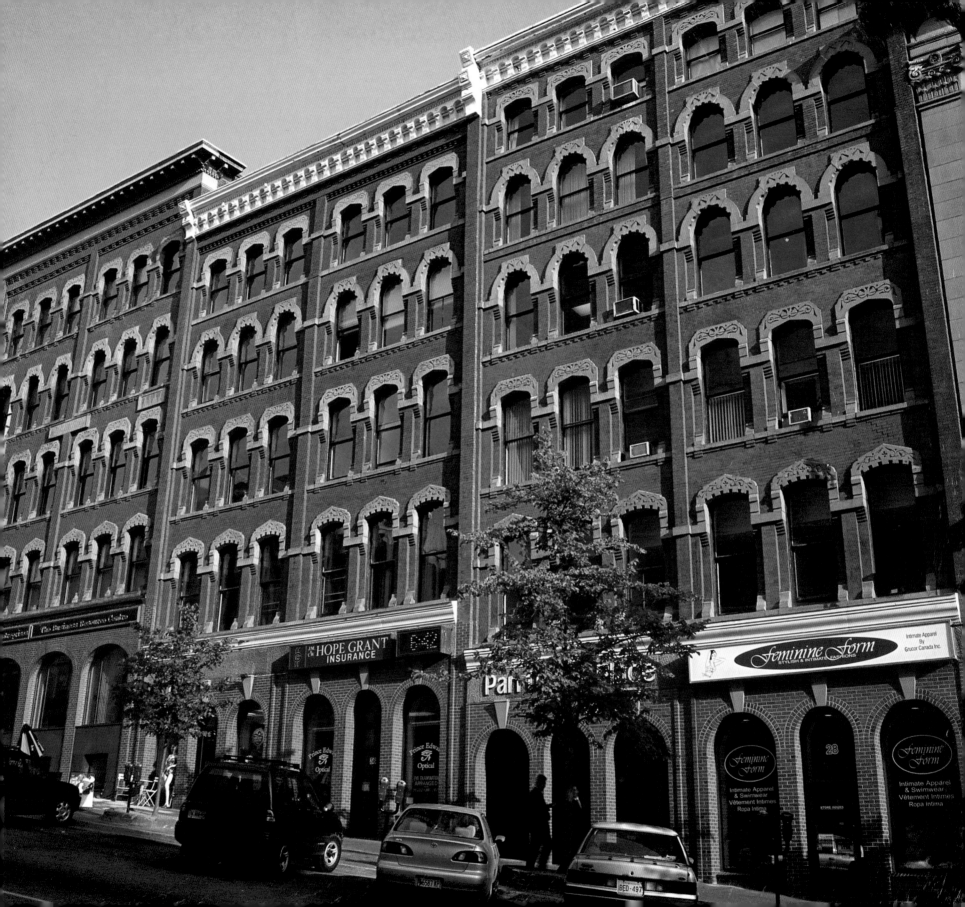

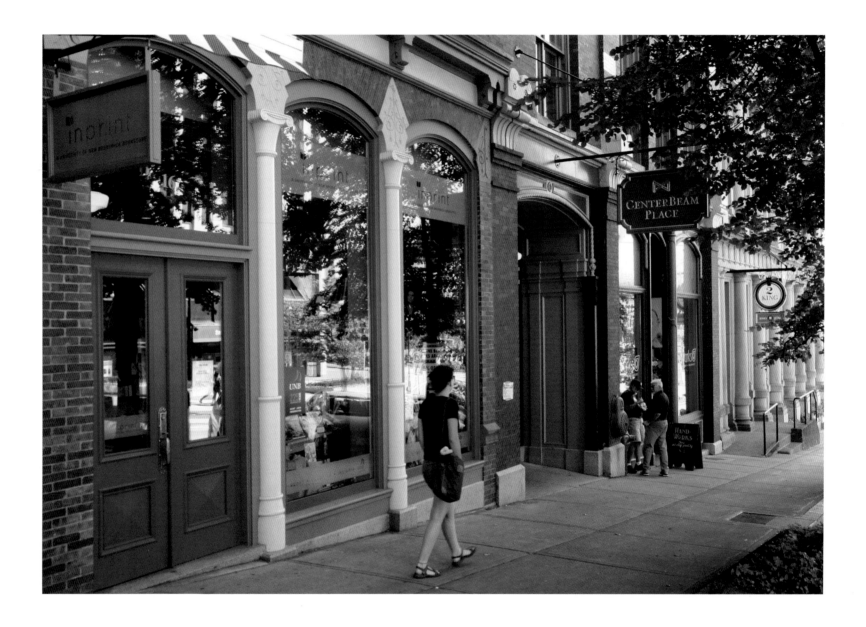

Centrebeam Place combines a storefront ambience with an interior mall format giving access to the same shops from the inside. It also forms the spine of an entire city block that was restored and refurbished by Commercial Properties Ltd. combining a mixture of business, retail, and dining facilities.